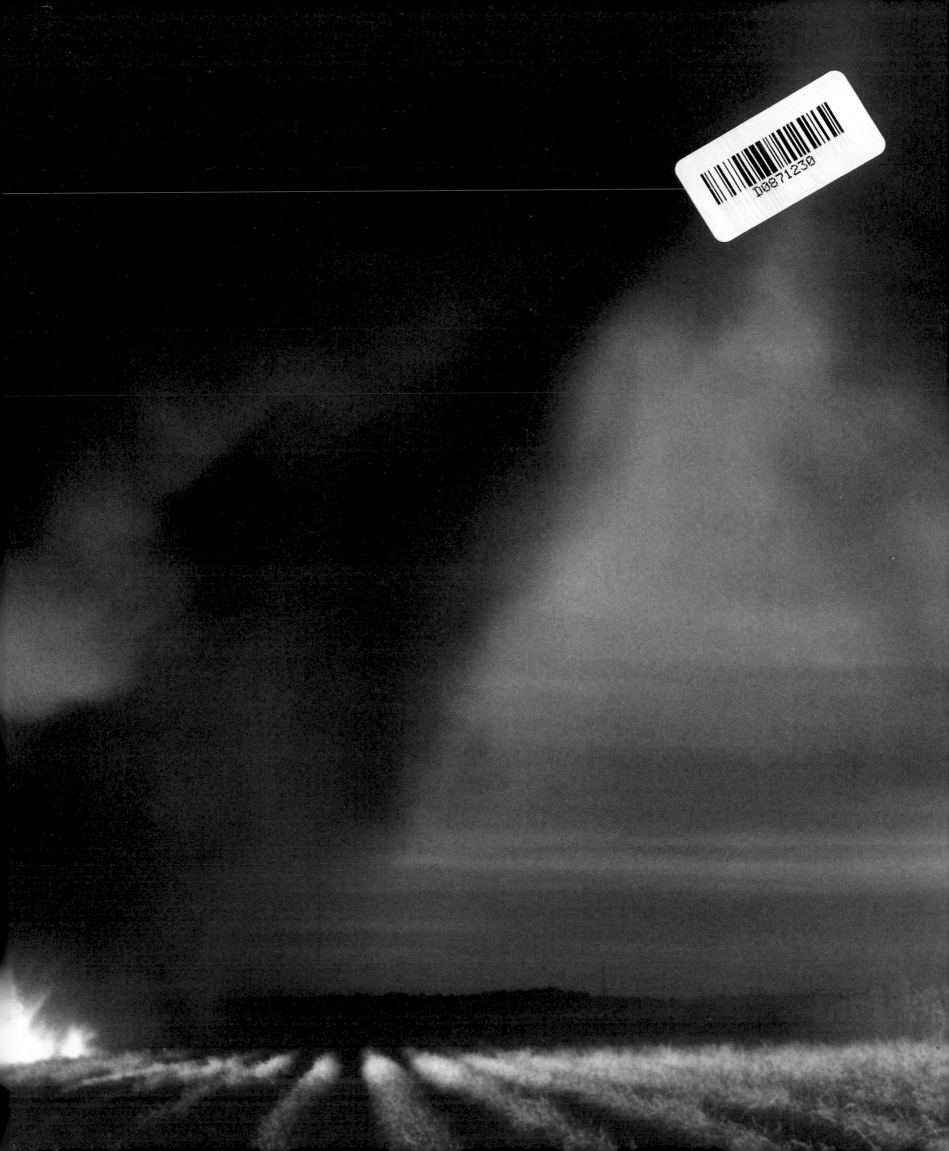

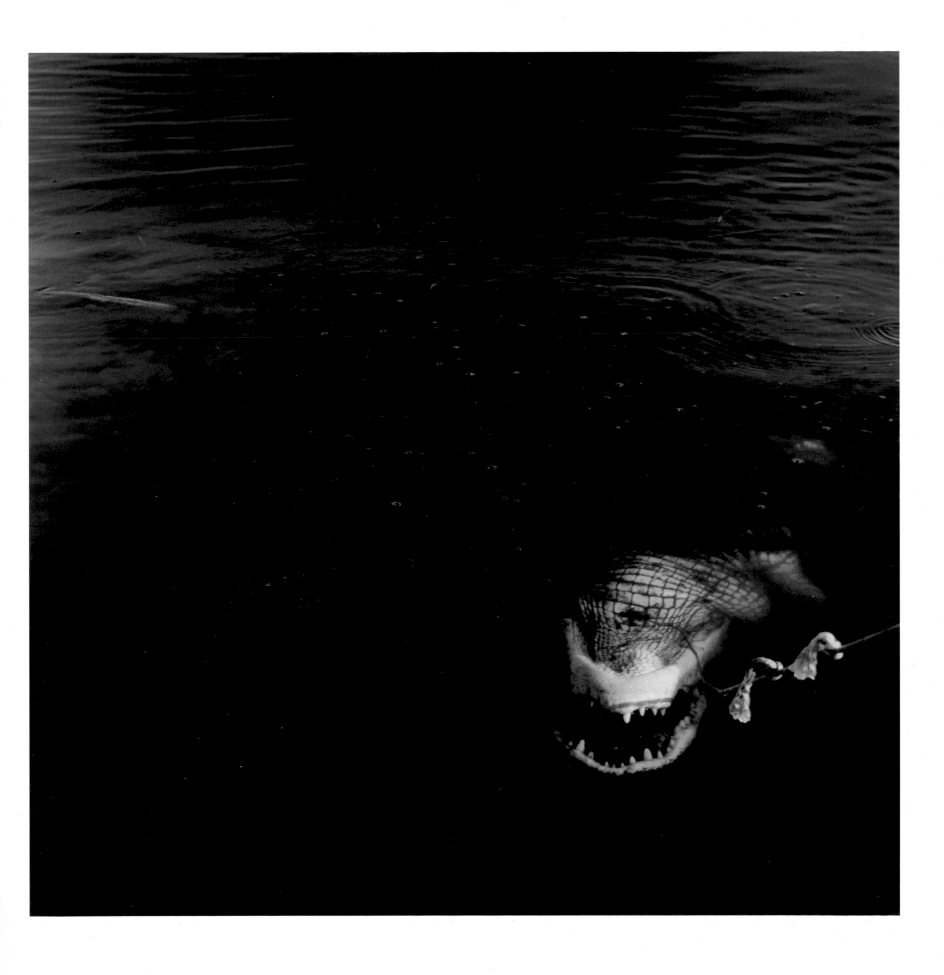

Debbie Fleming Caffery

The Shadows

TWIN PALMS PUBLISHERS
2002

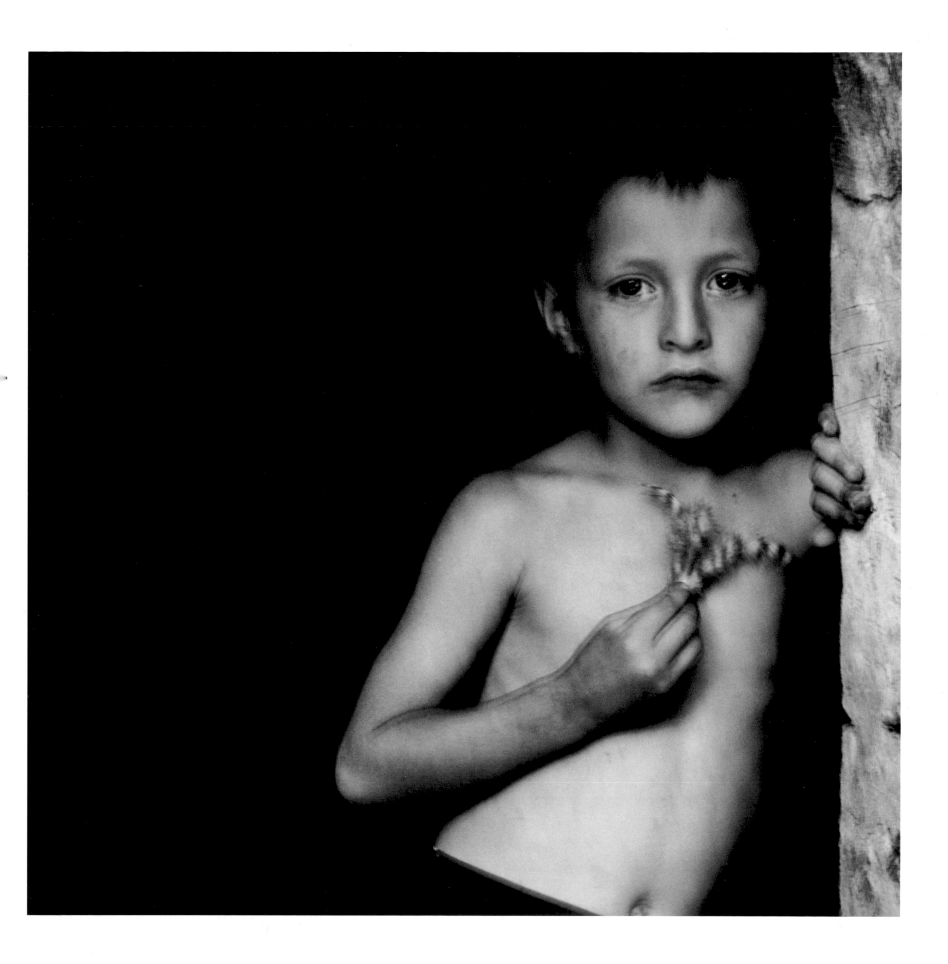

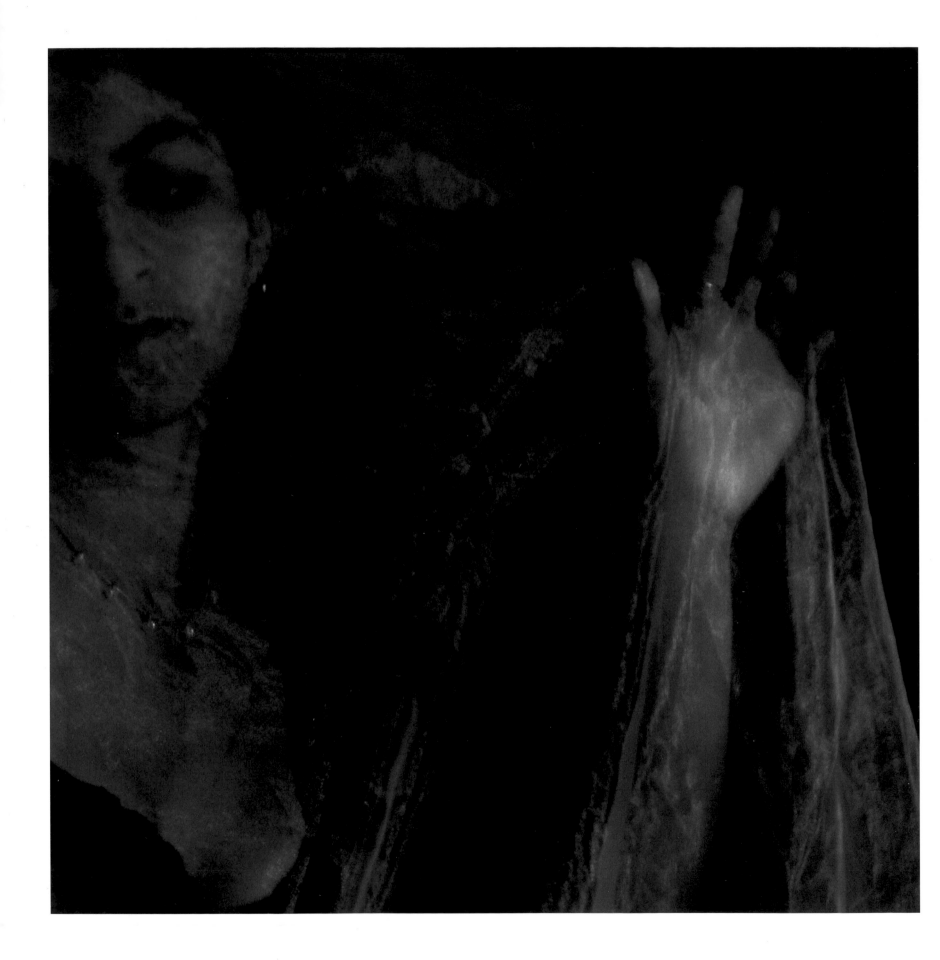

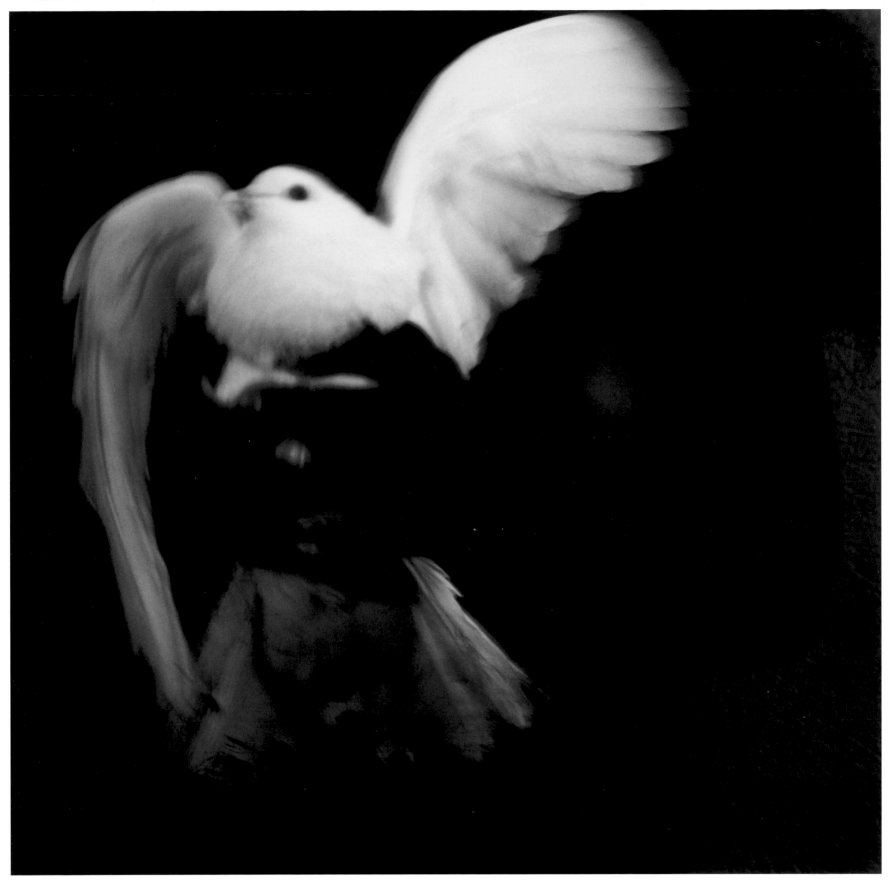

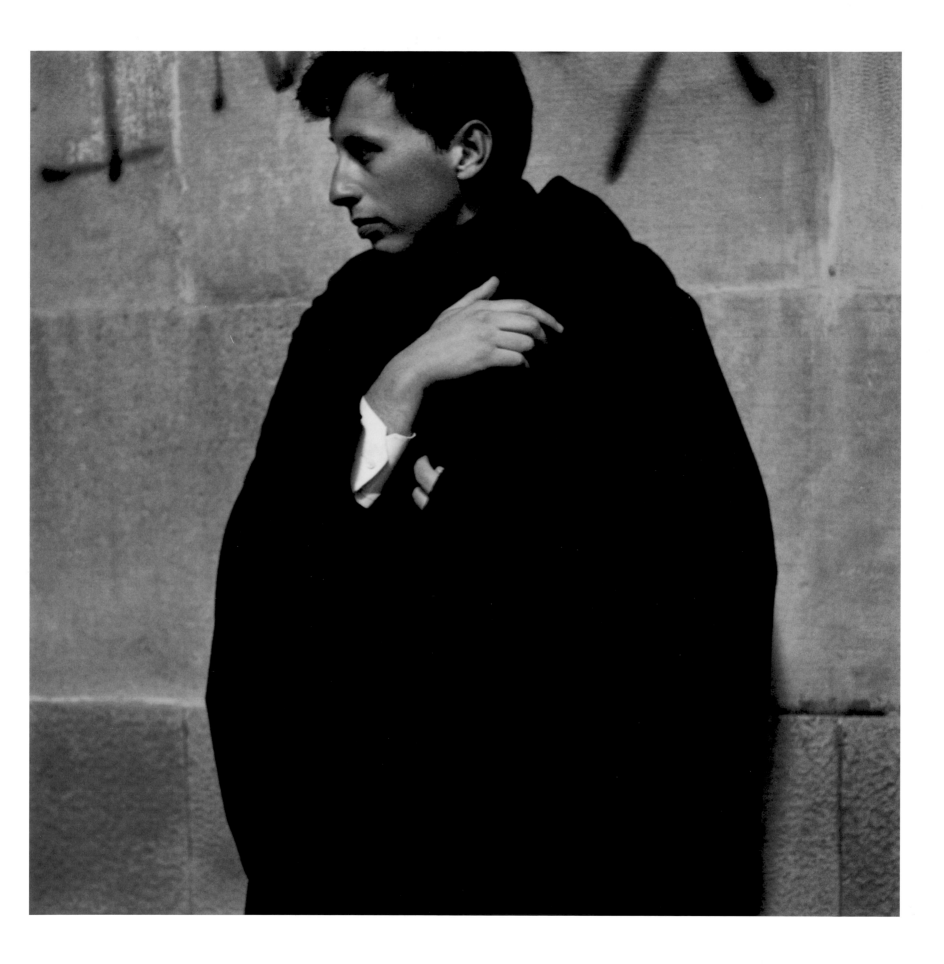

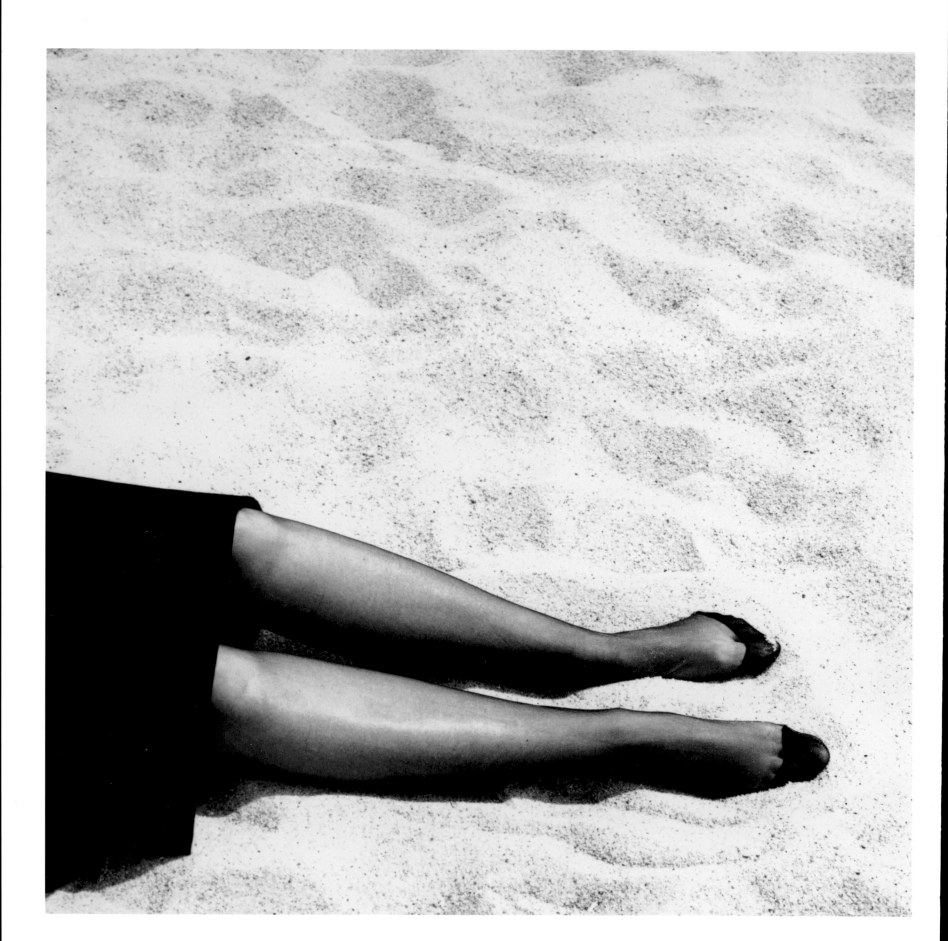

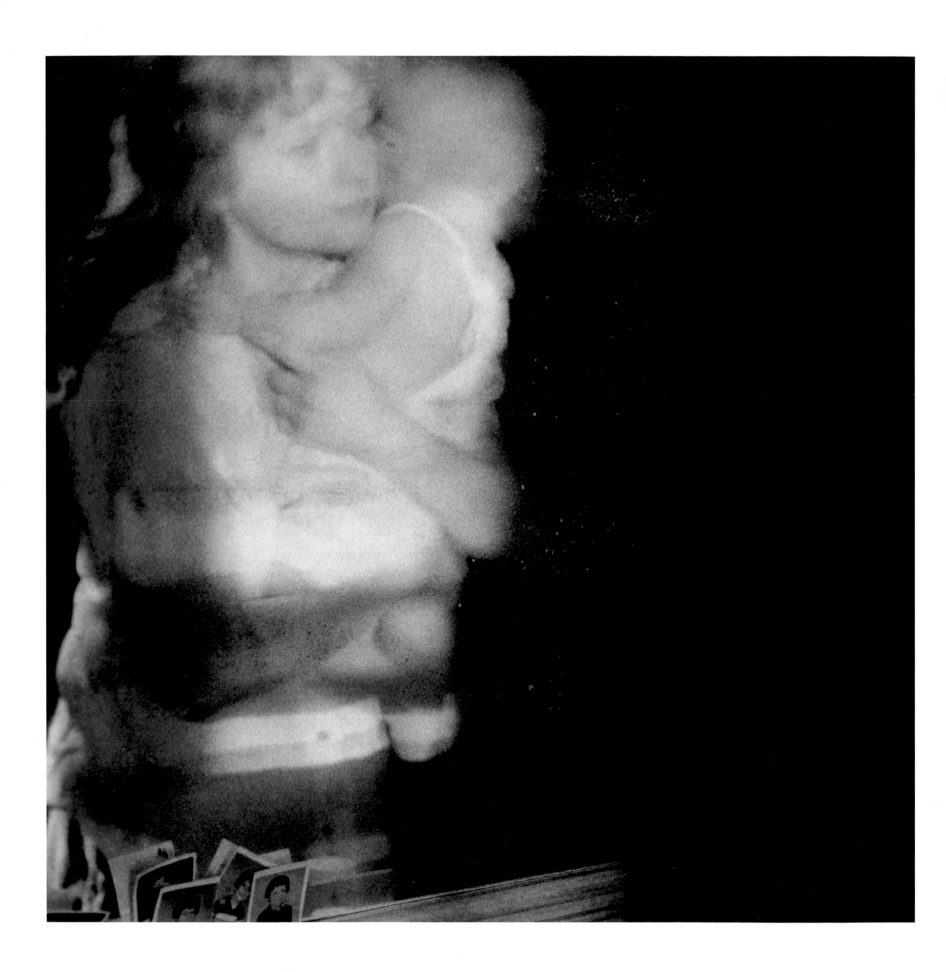

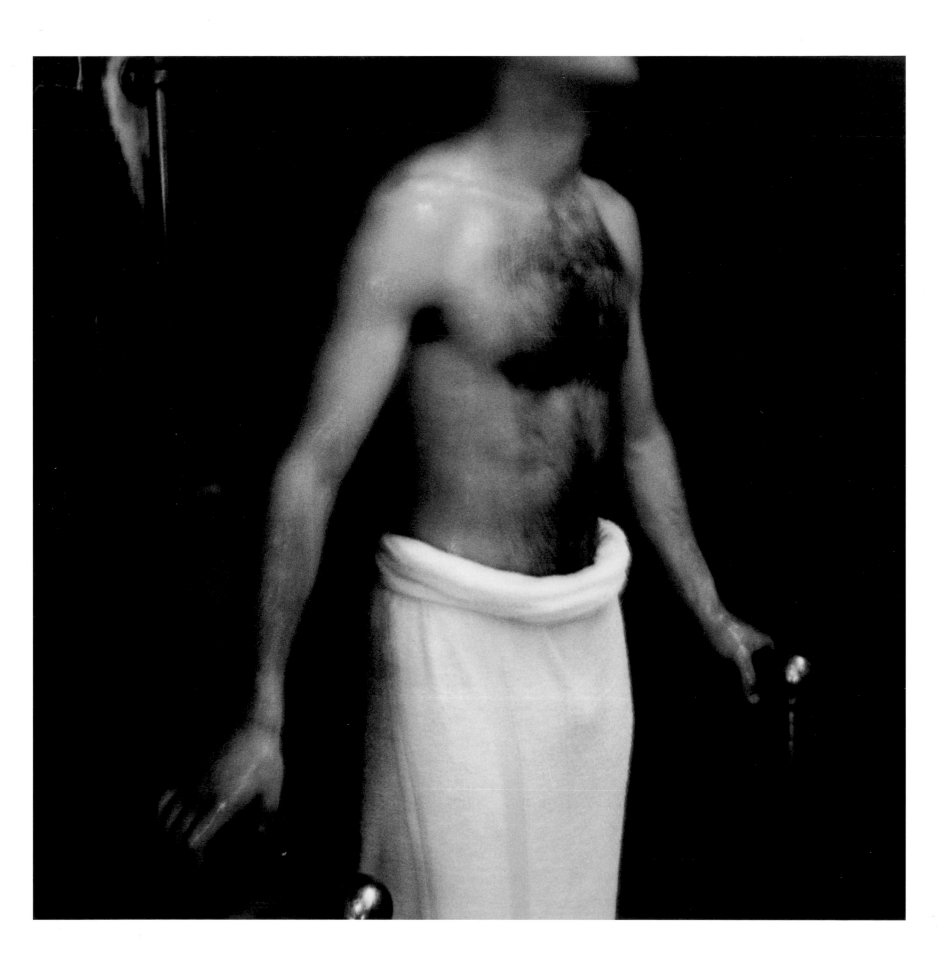

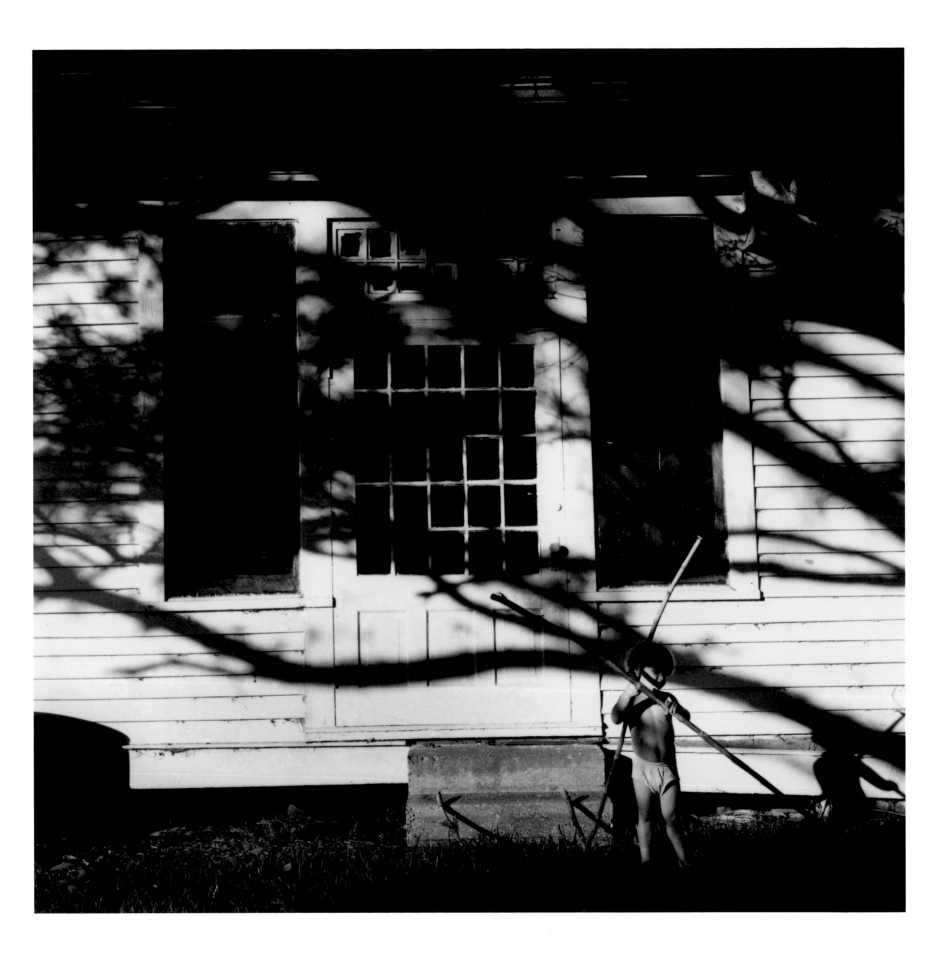

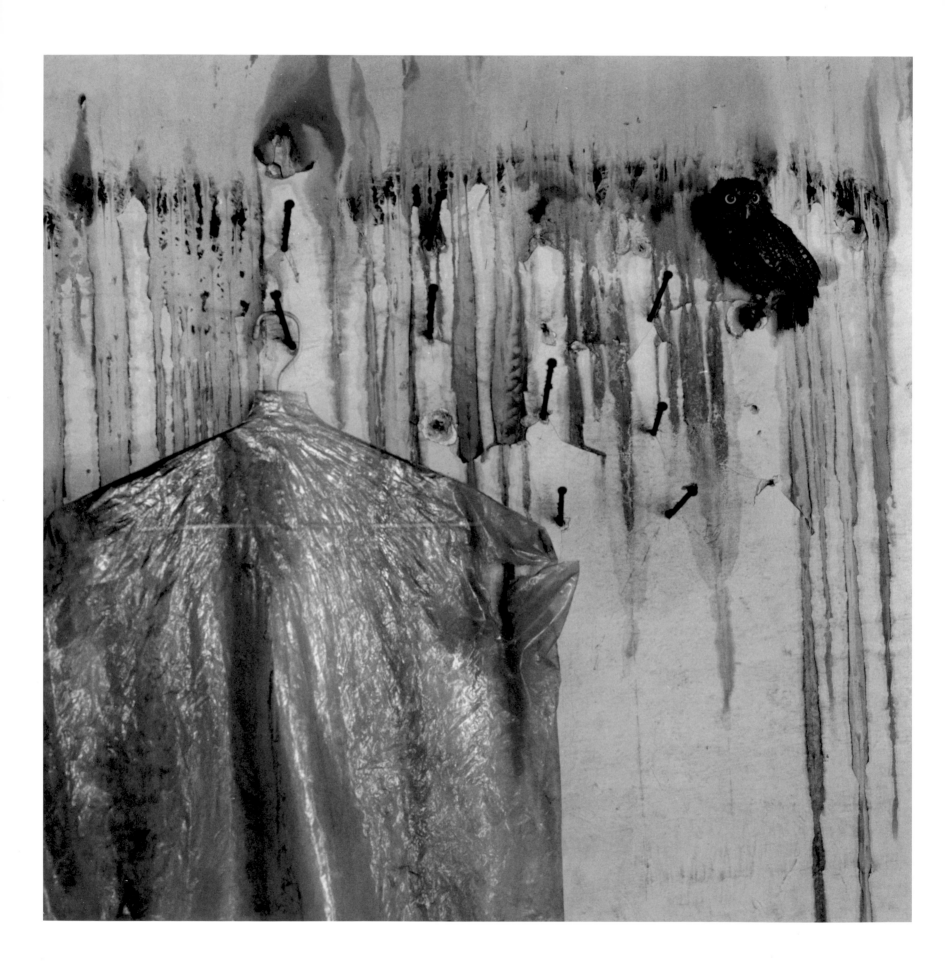

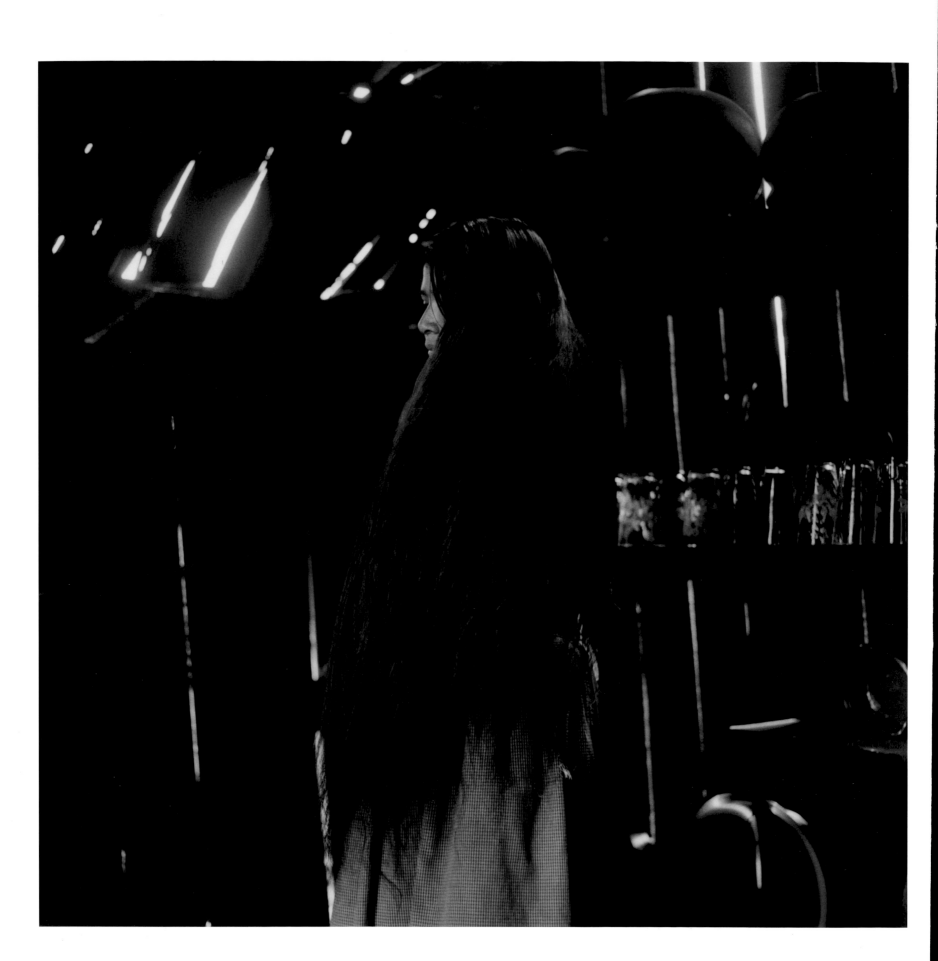

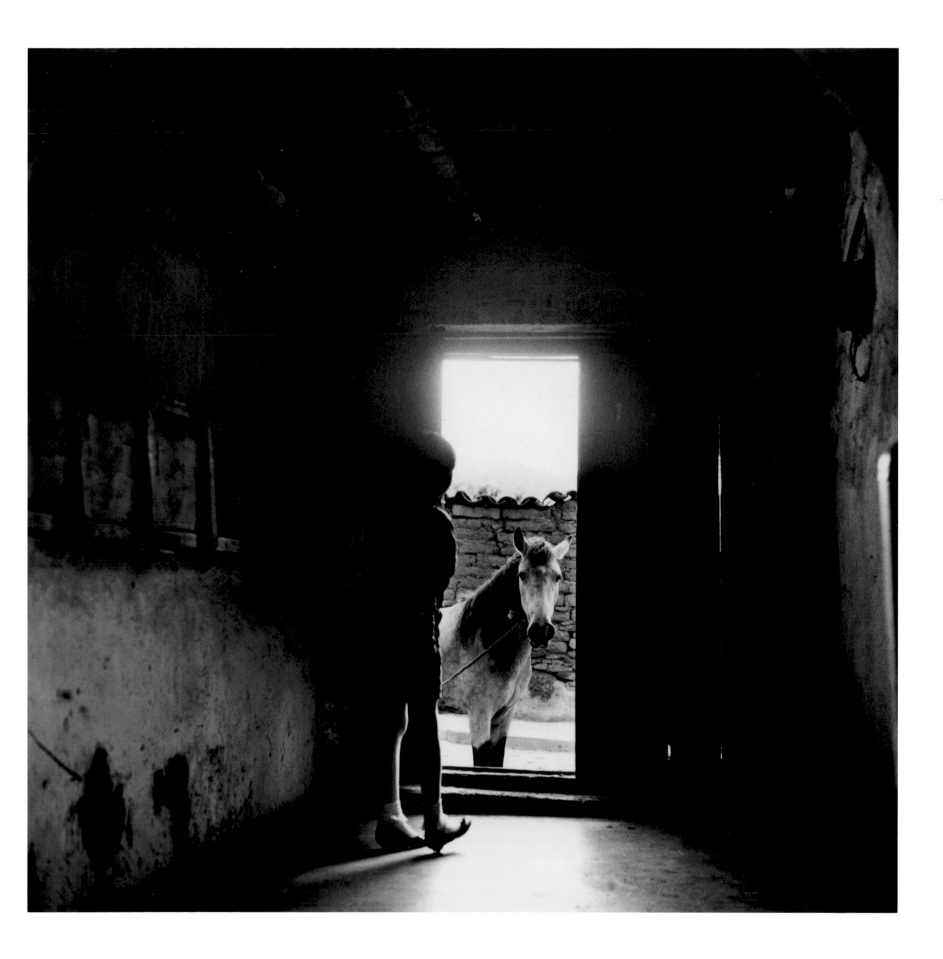

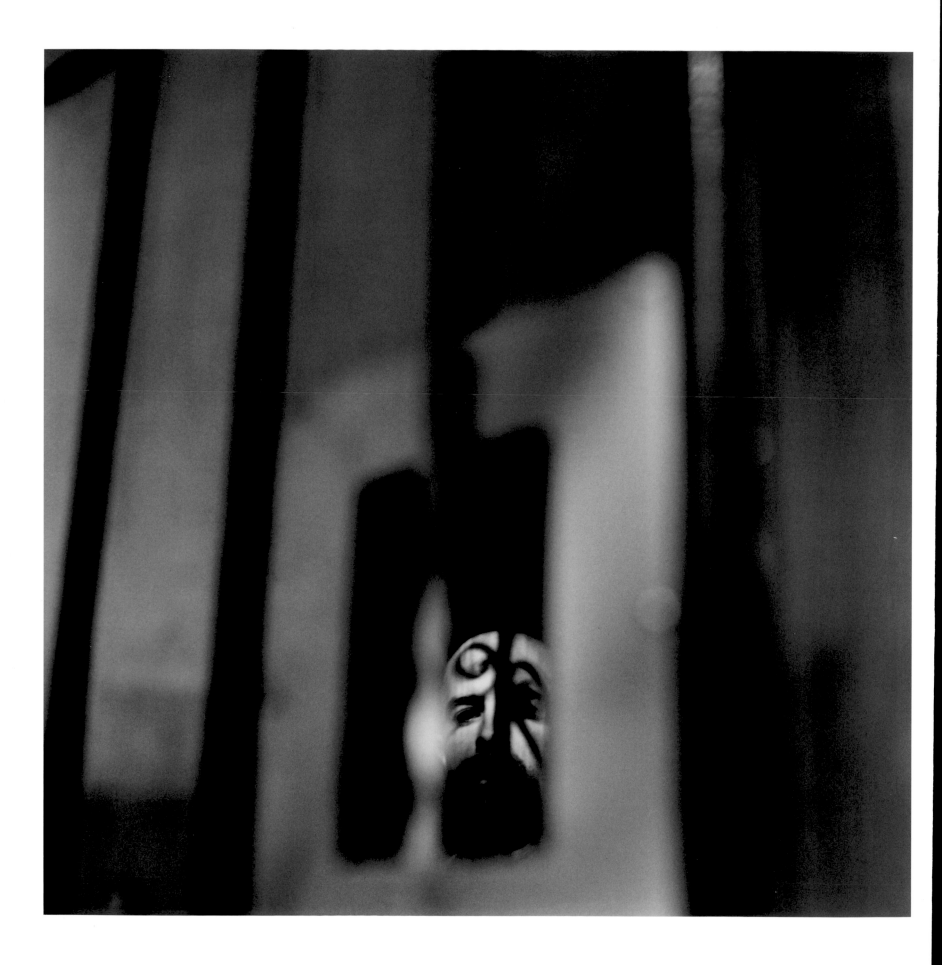

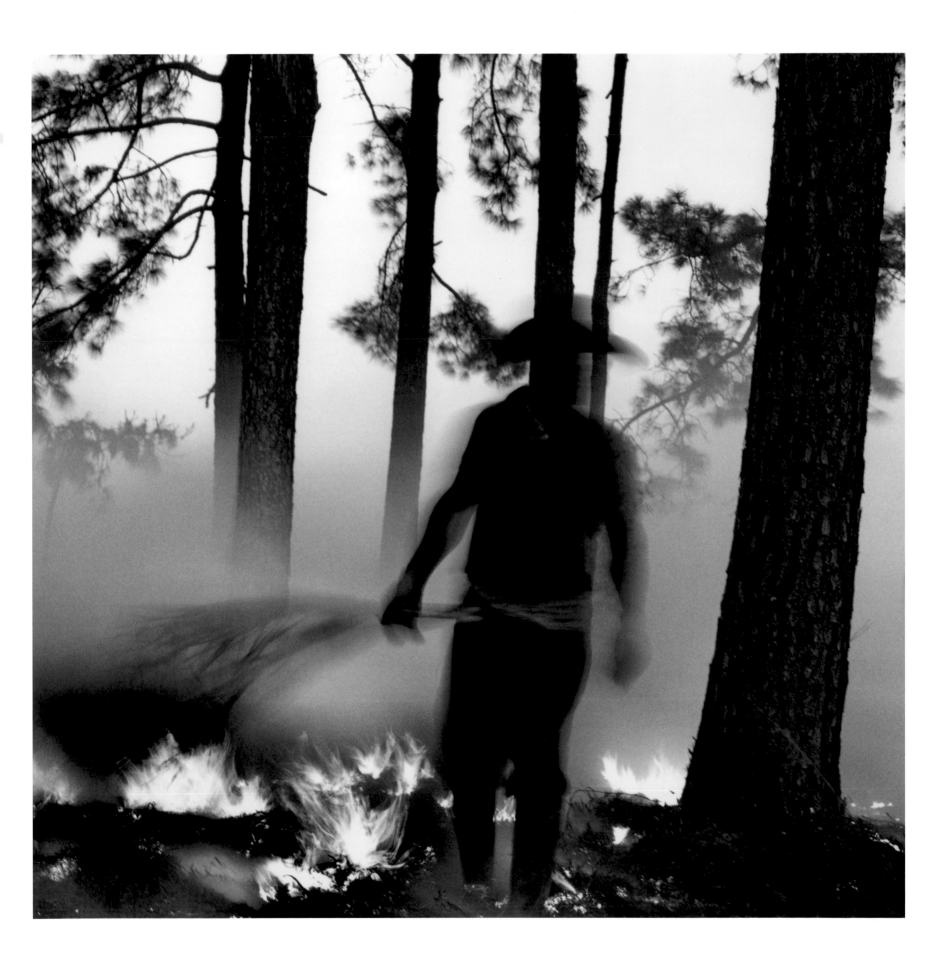

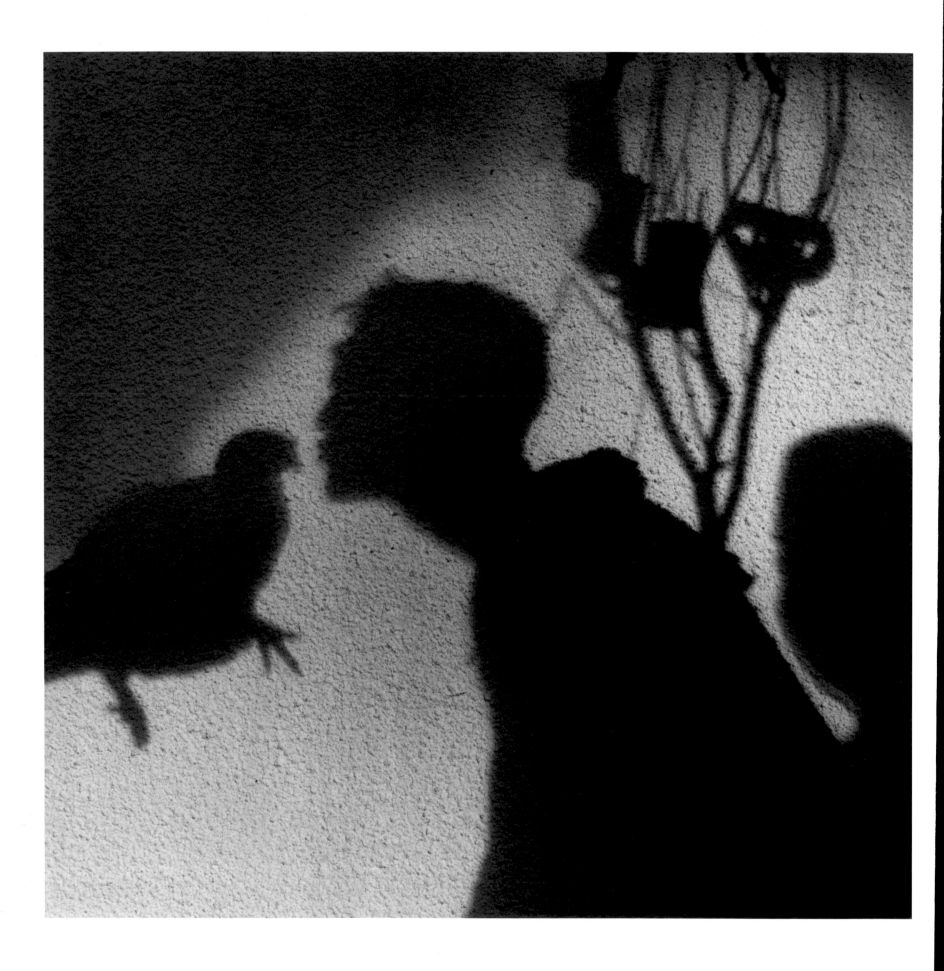

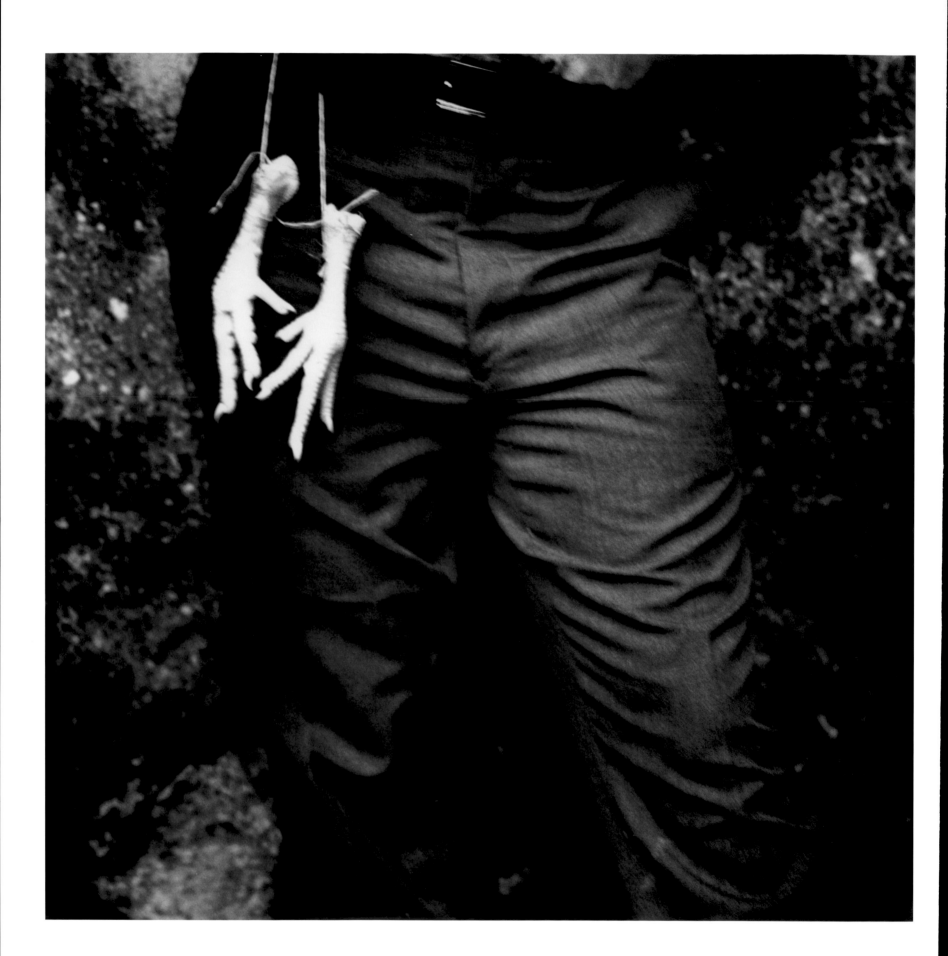

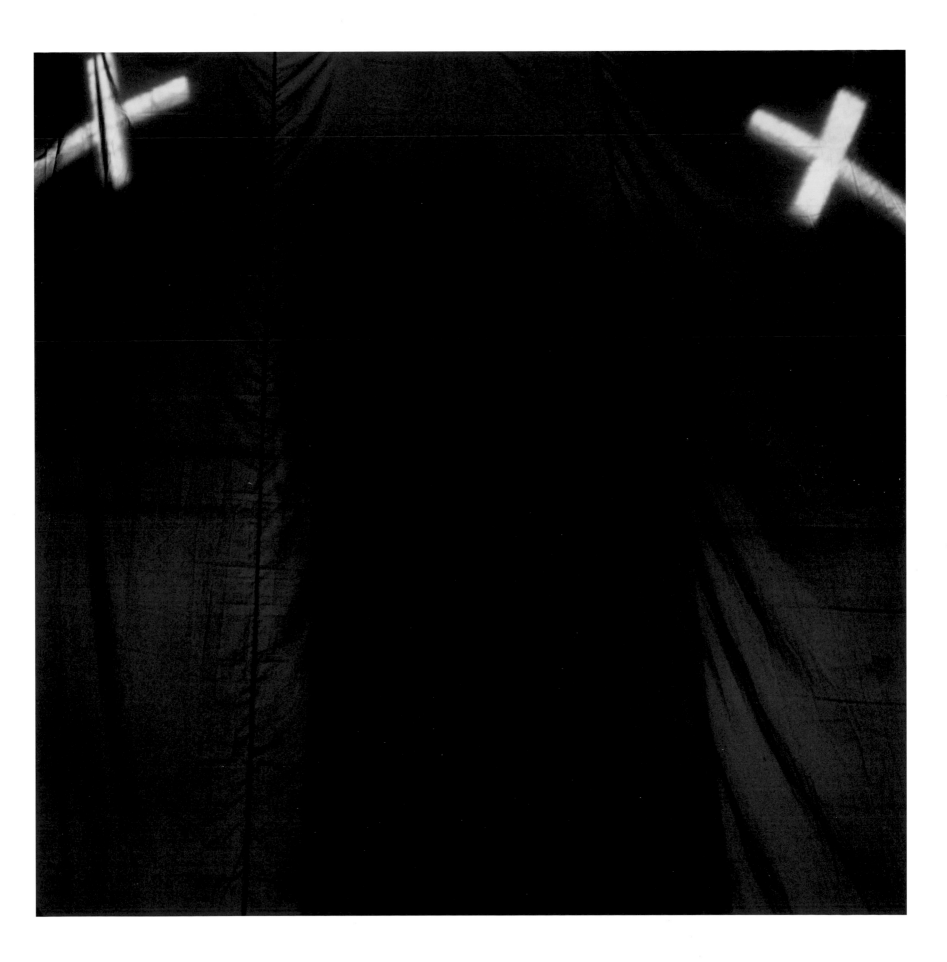

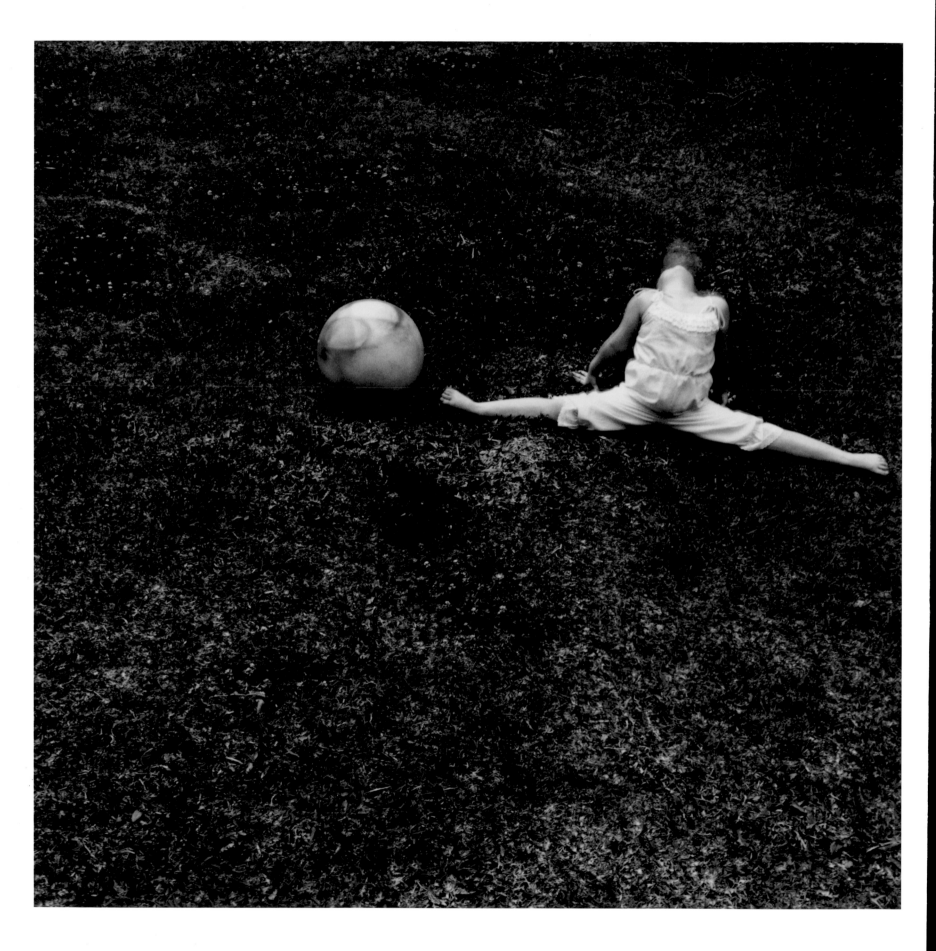

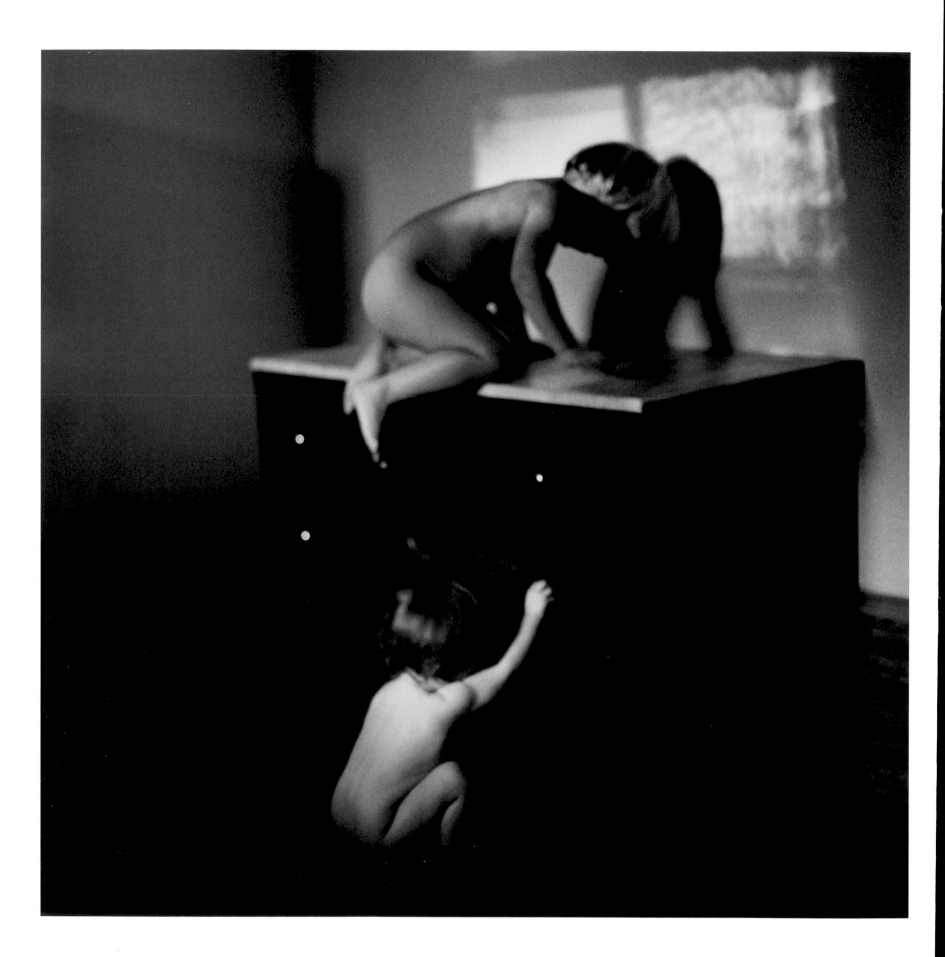

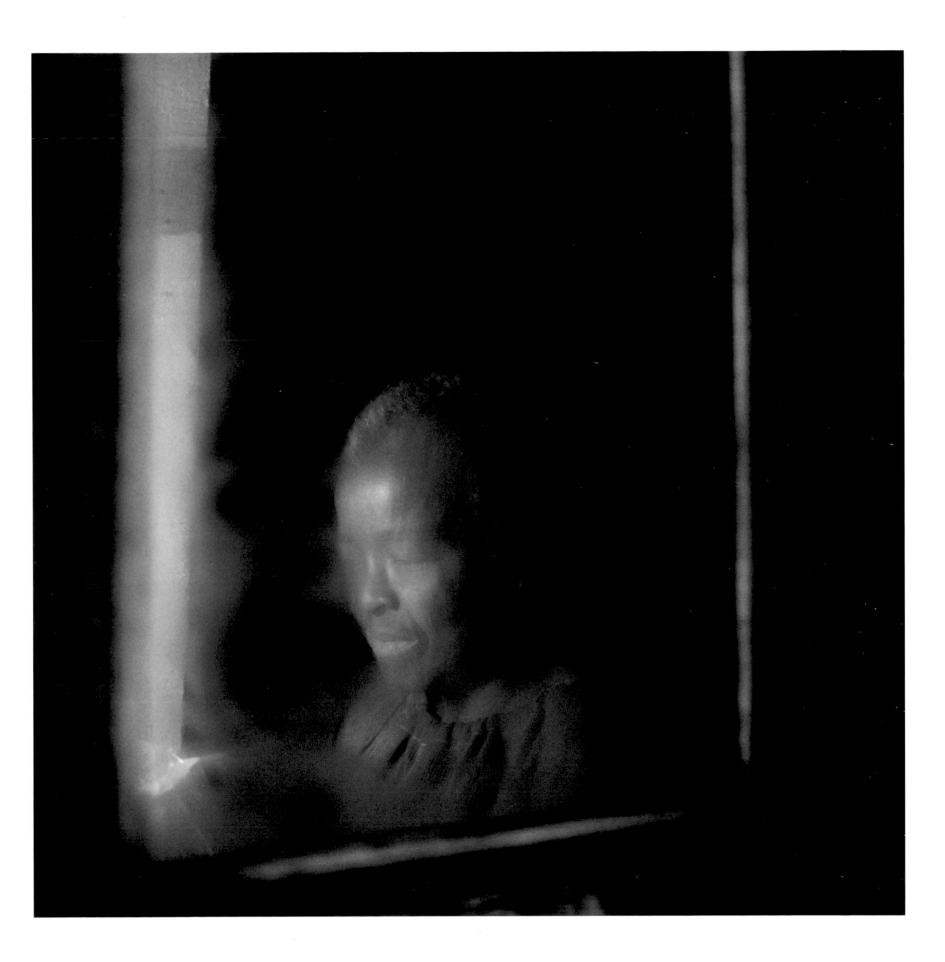

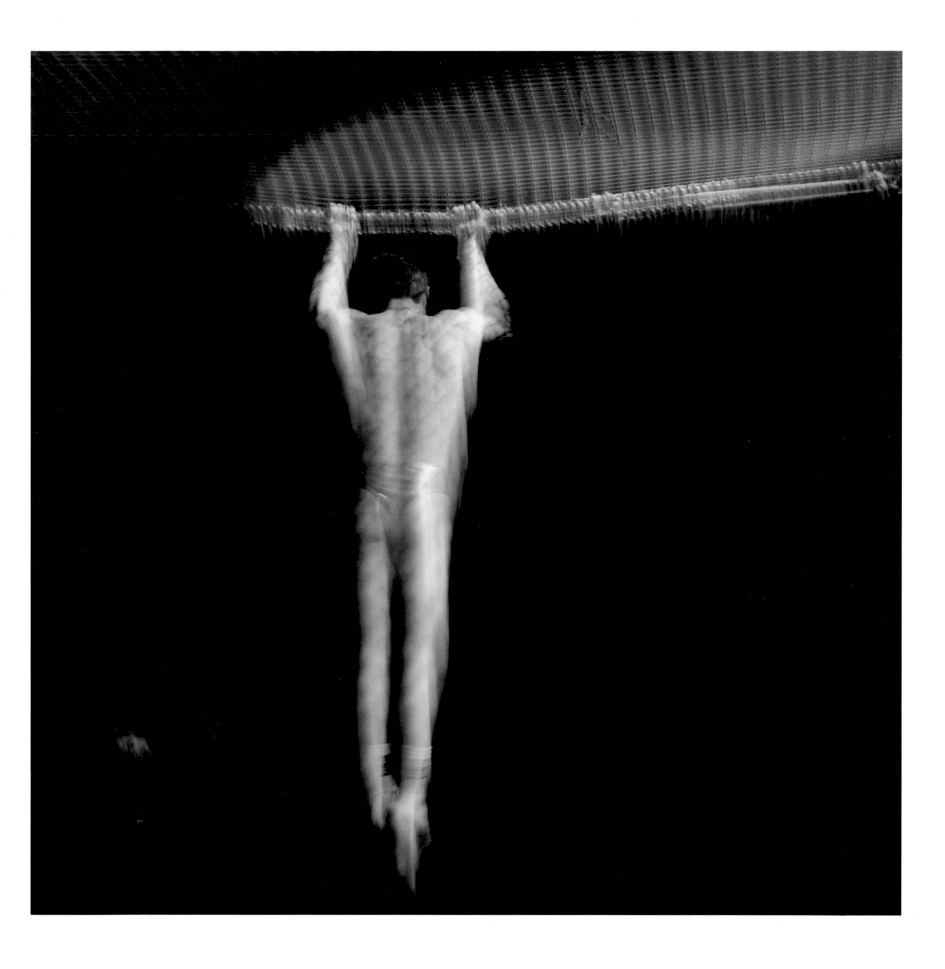

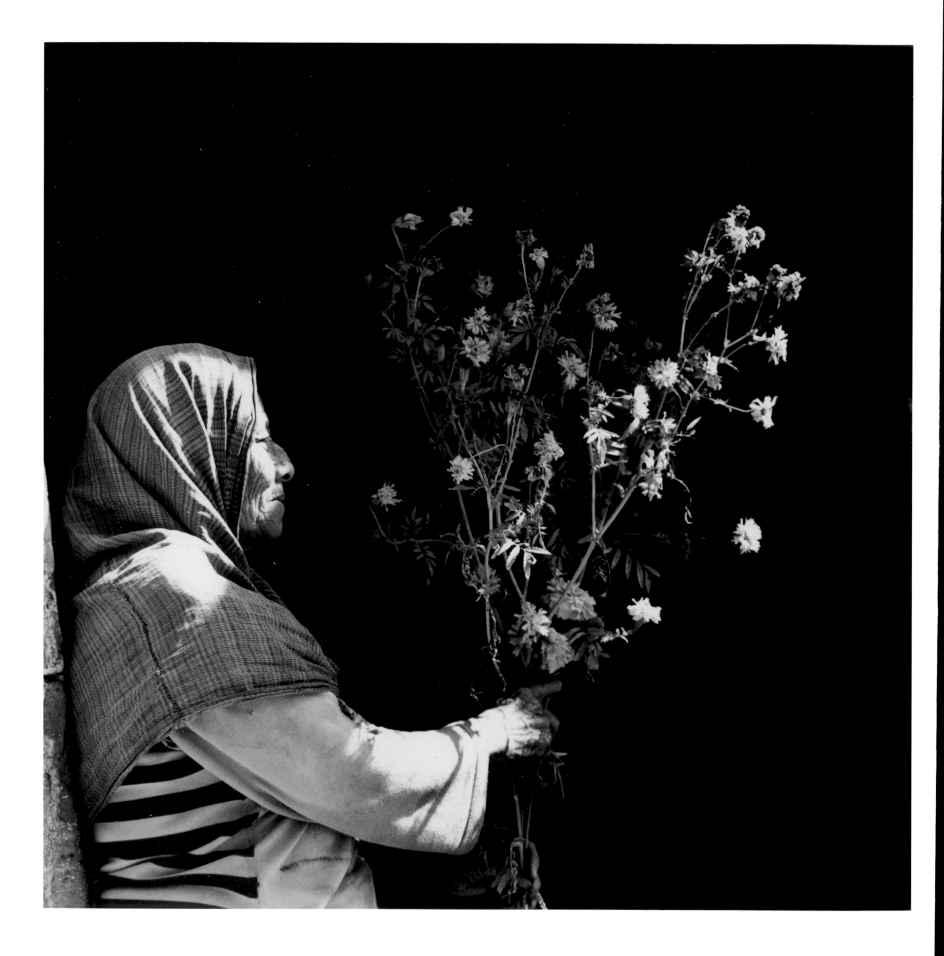

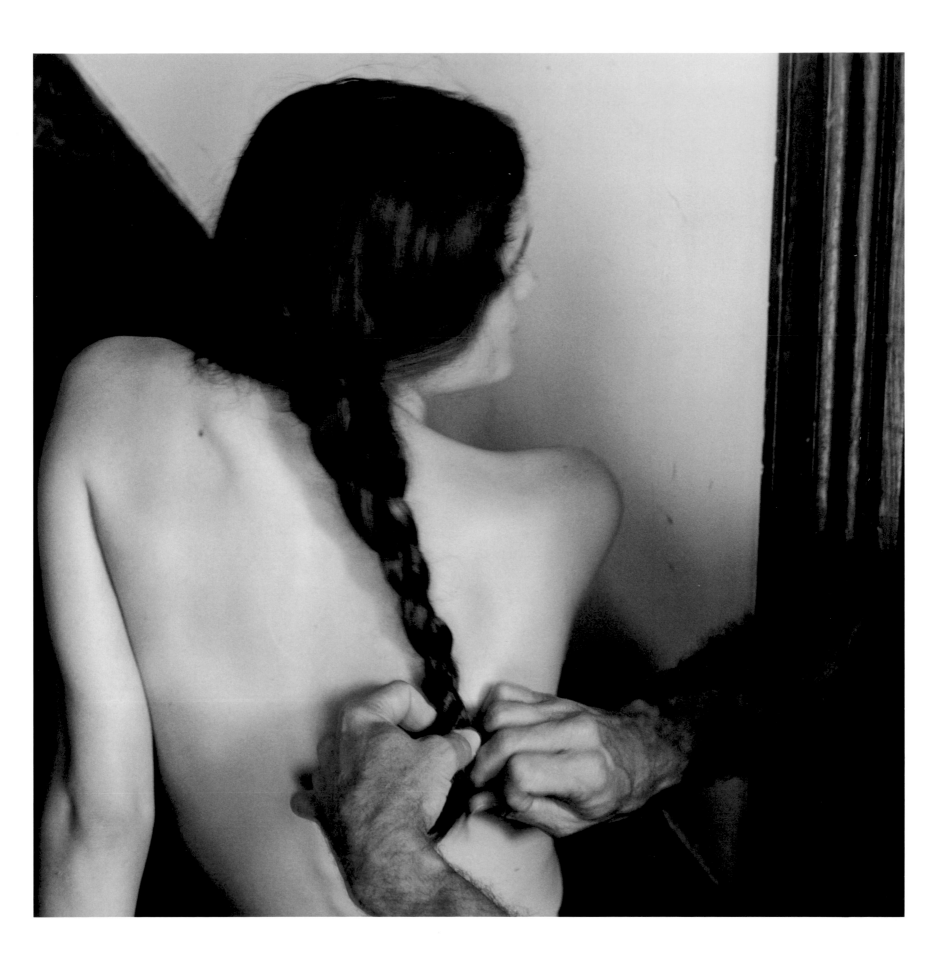

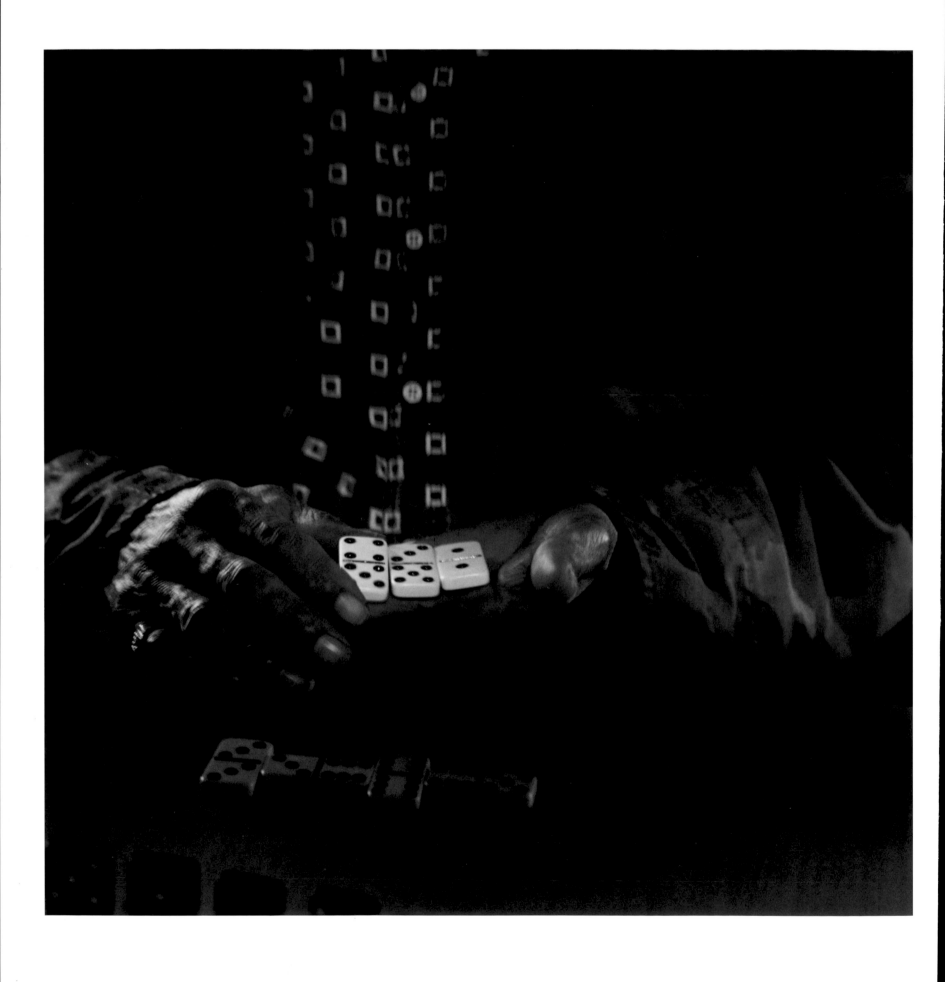

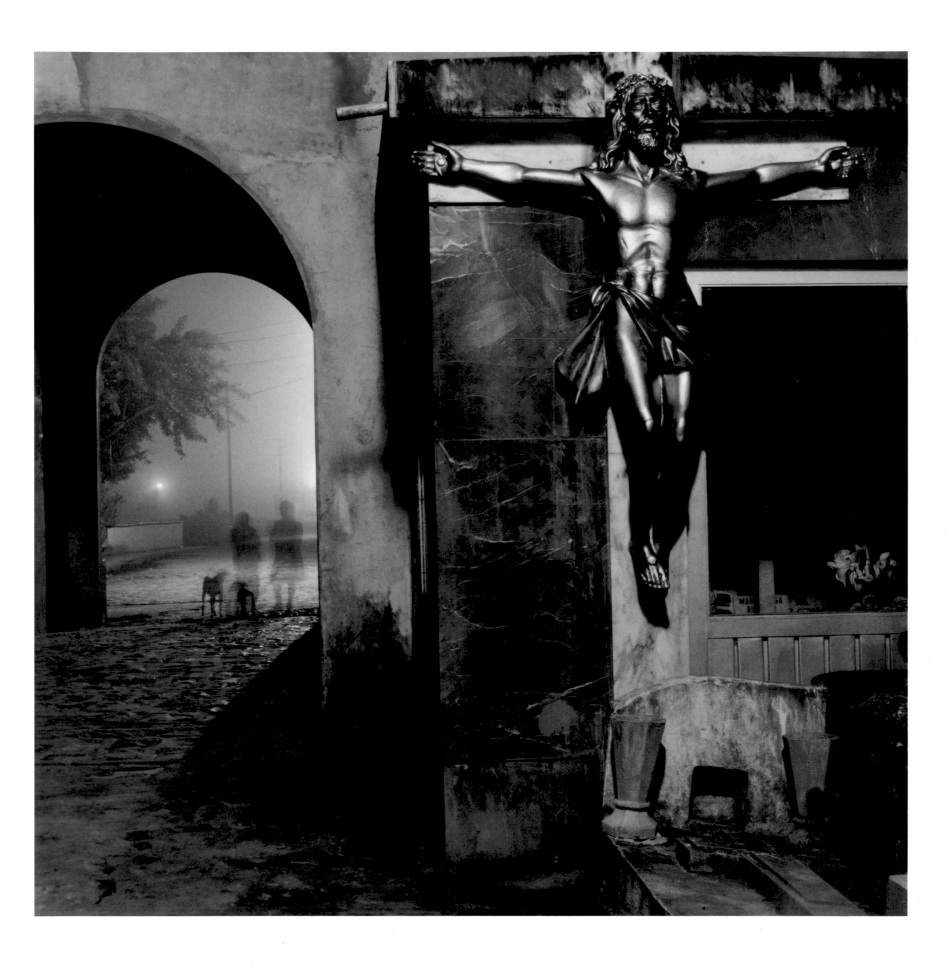

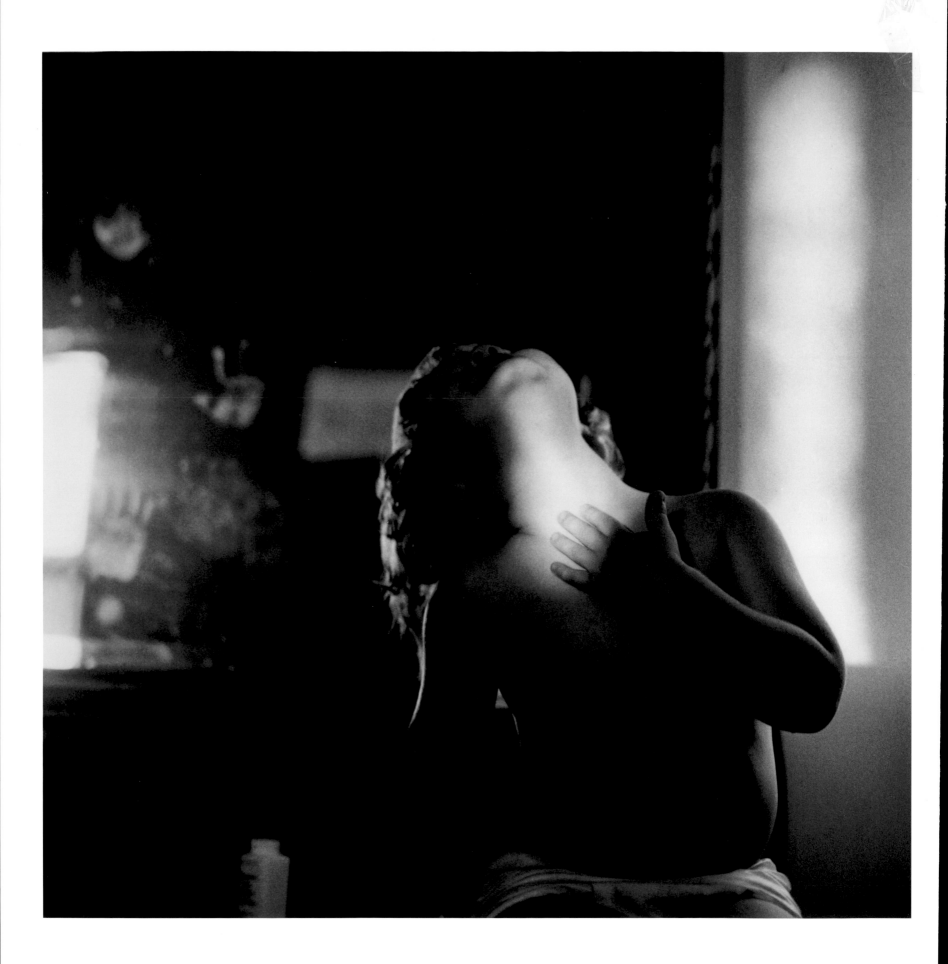

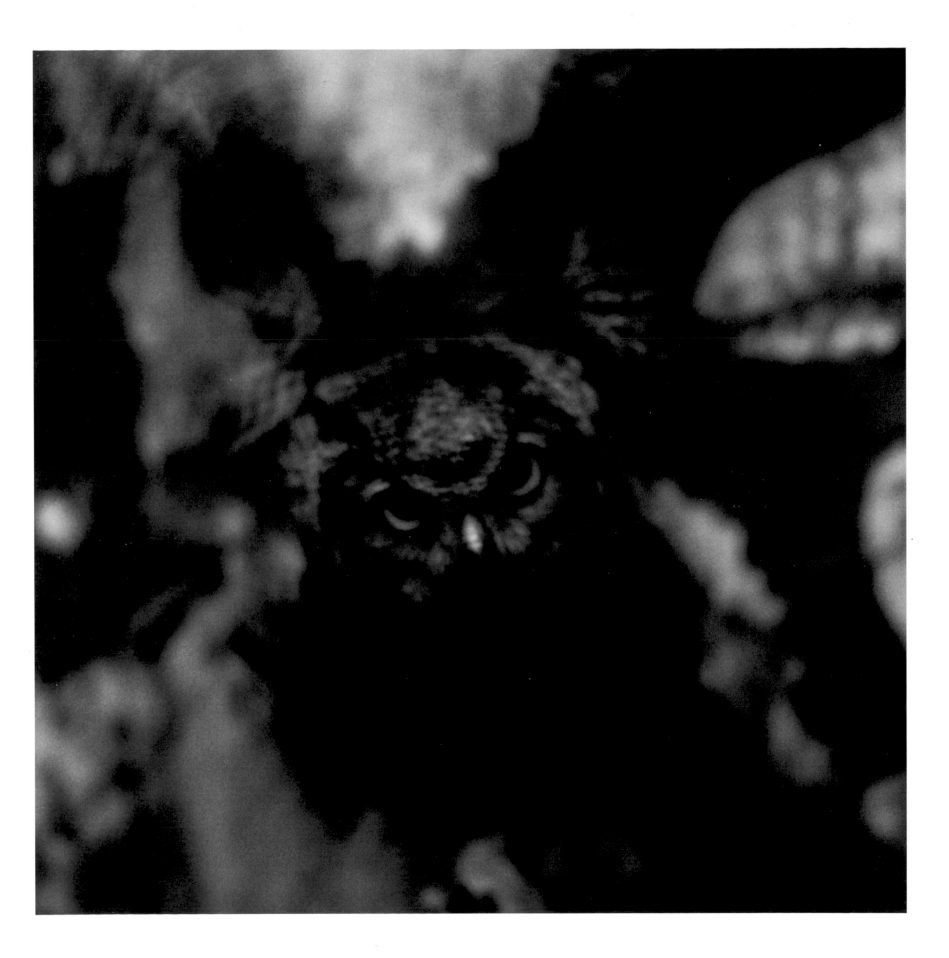

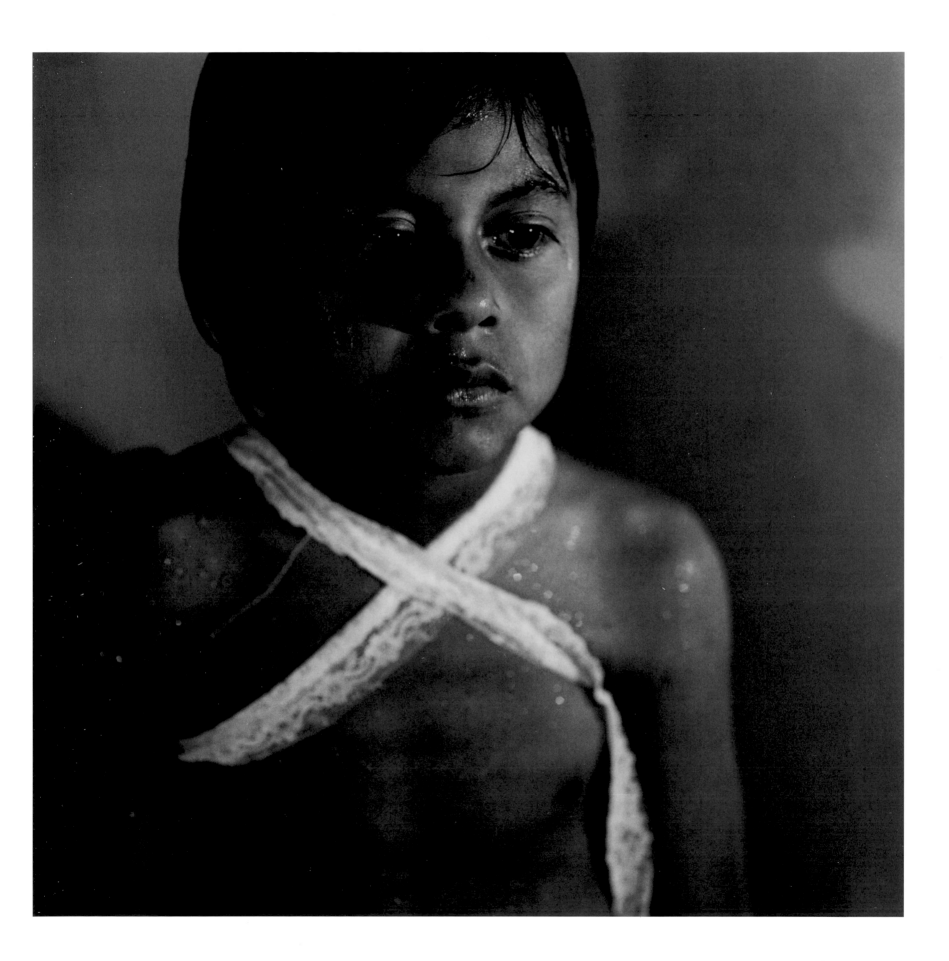

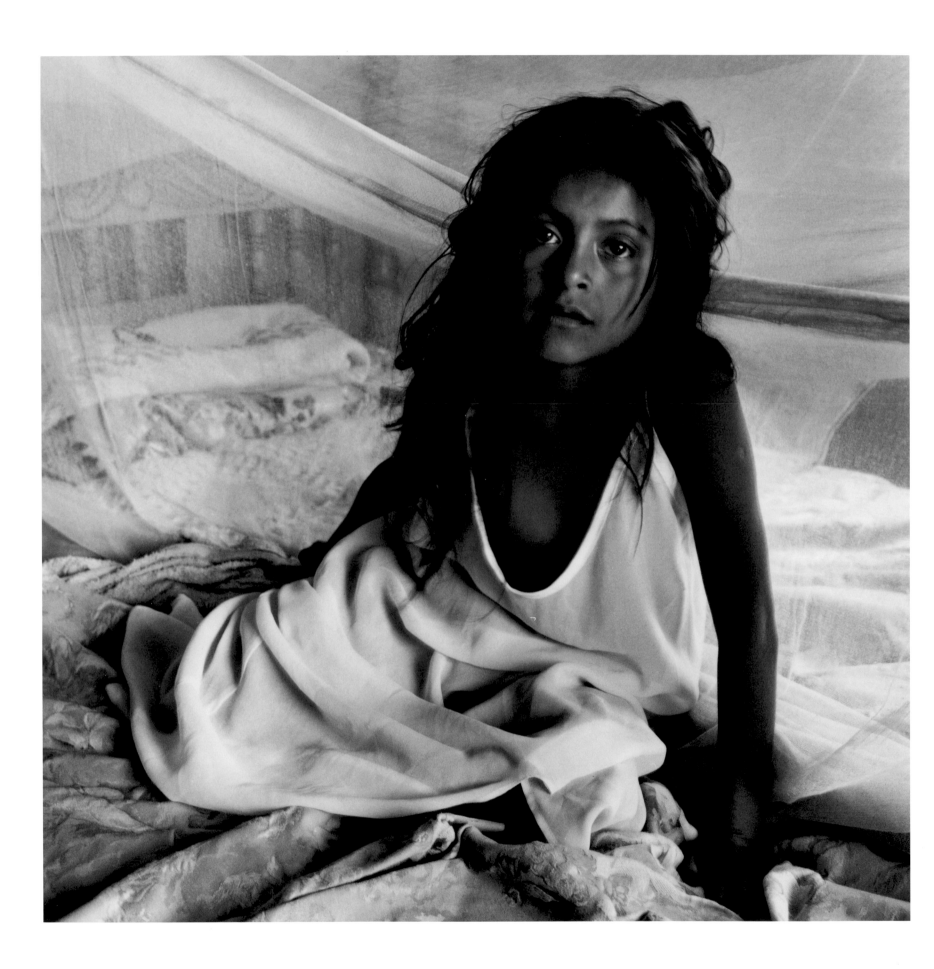

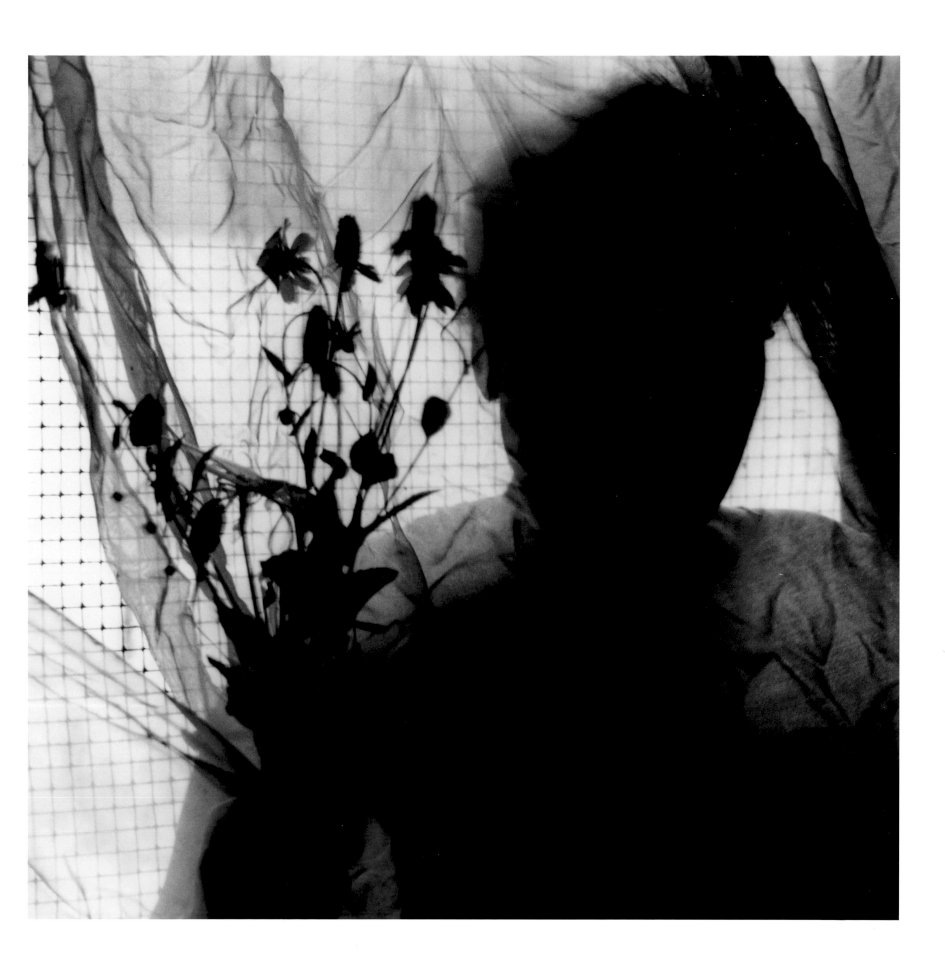

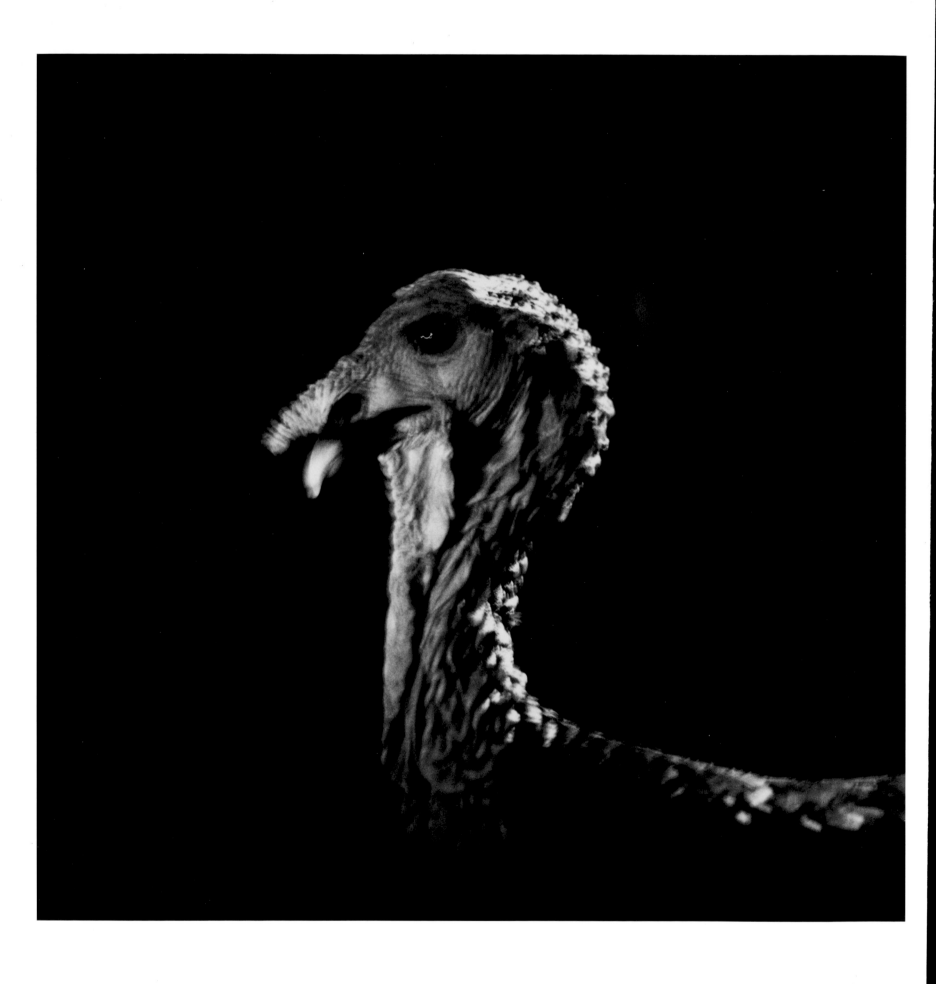

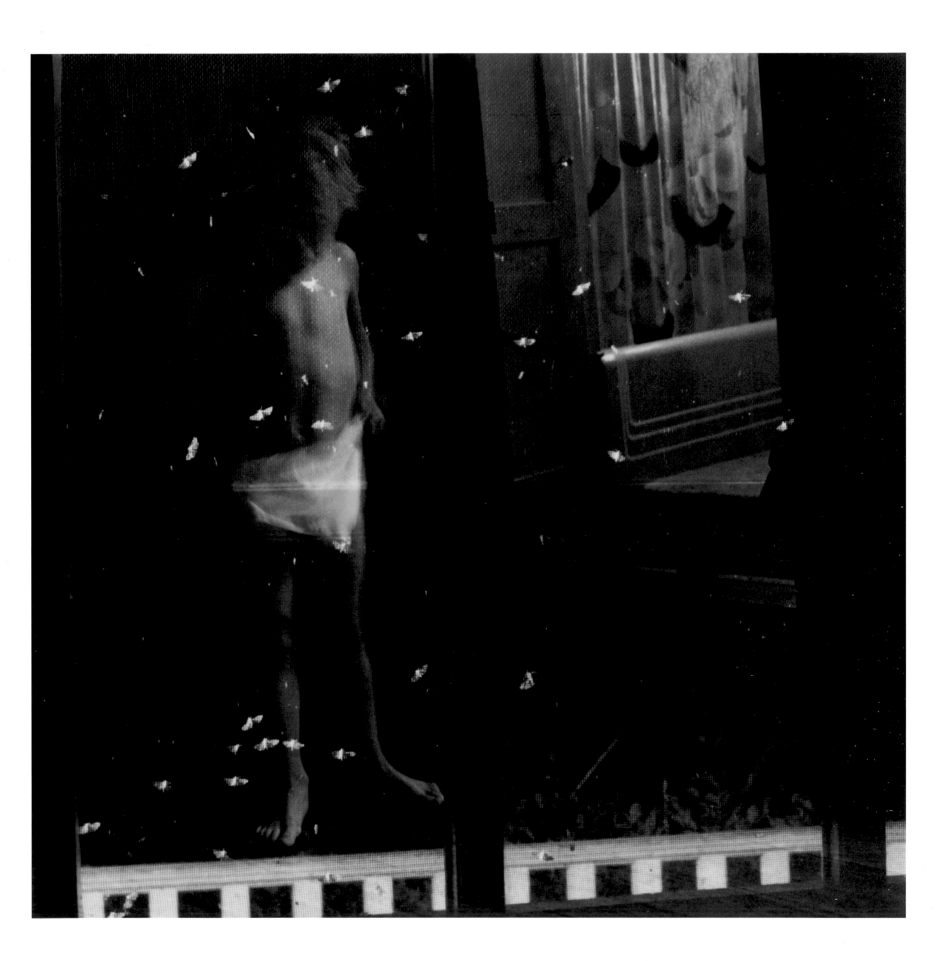

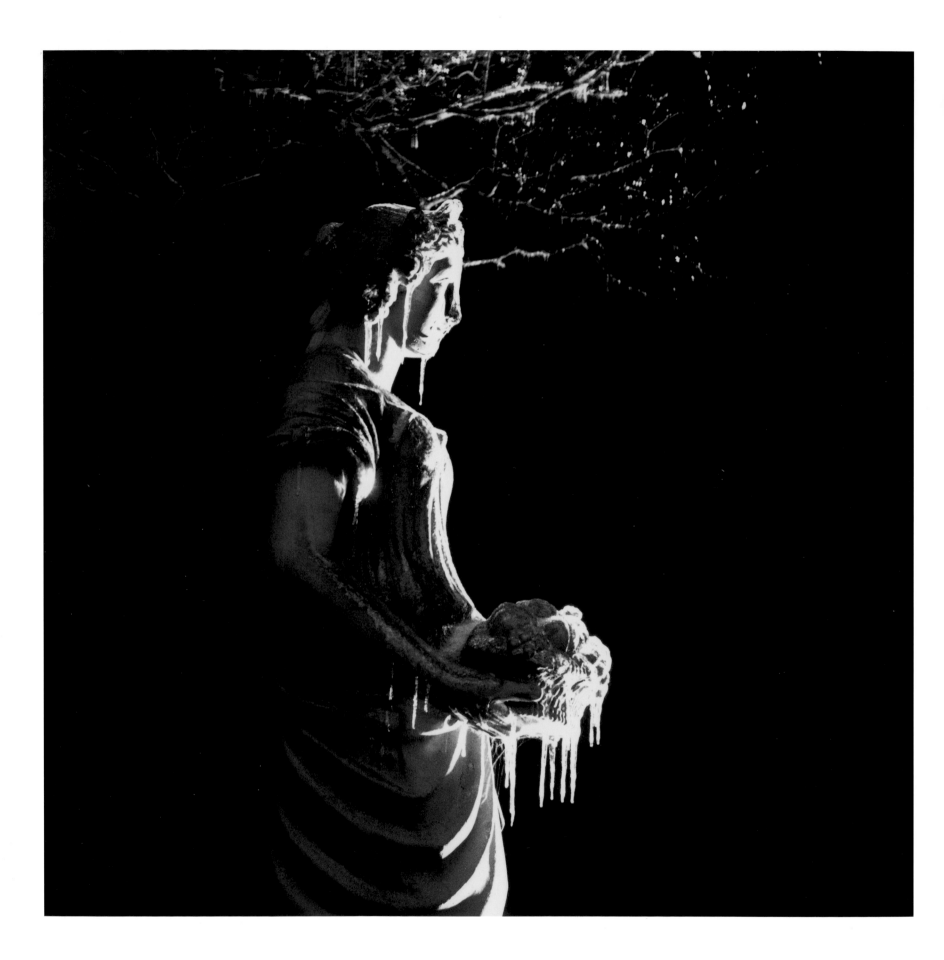

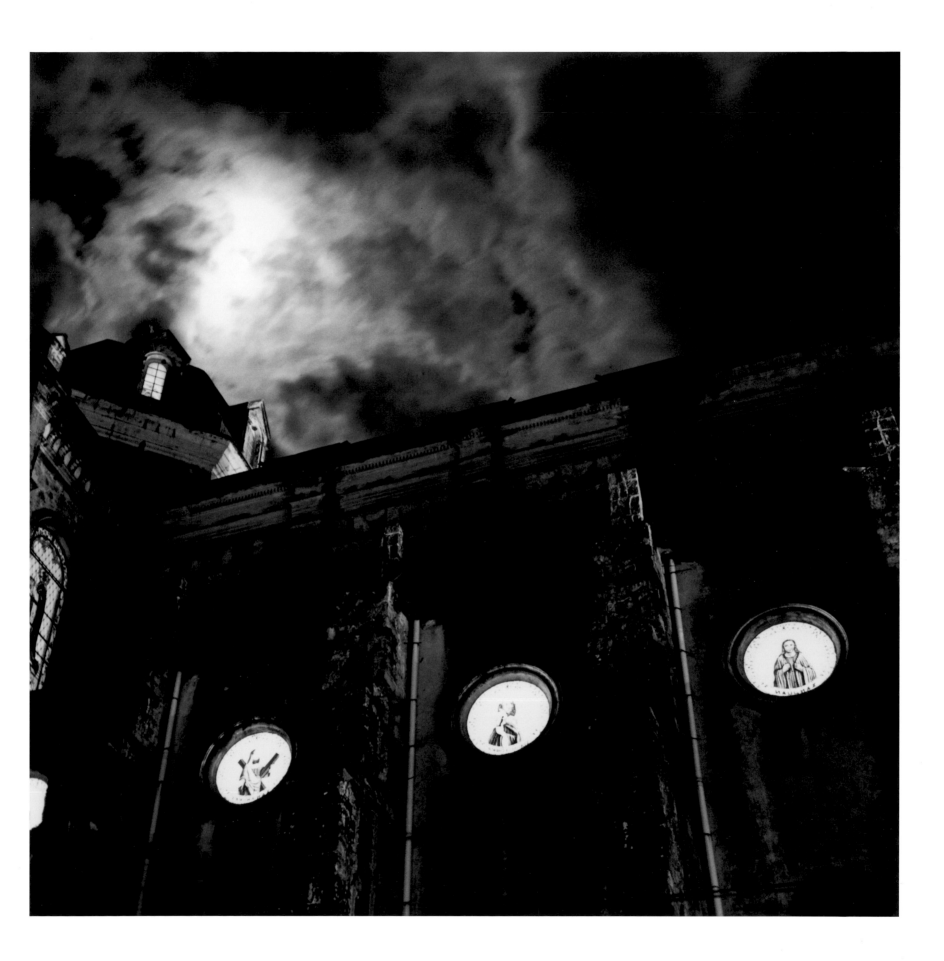

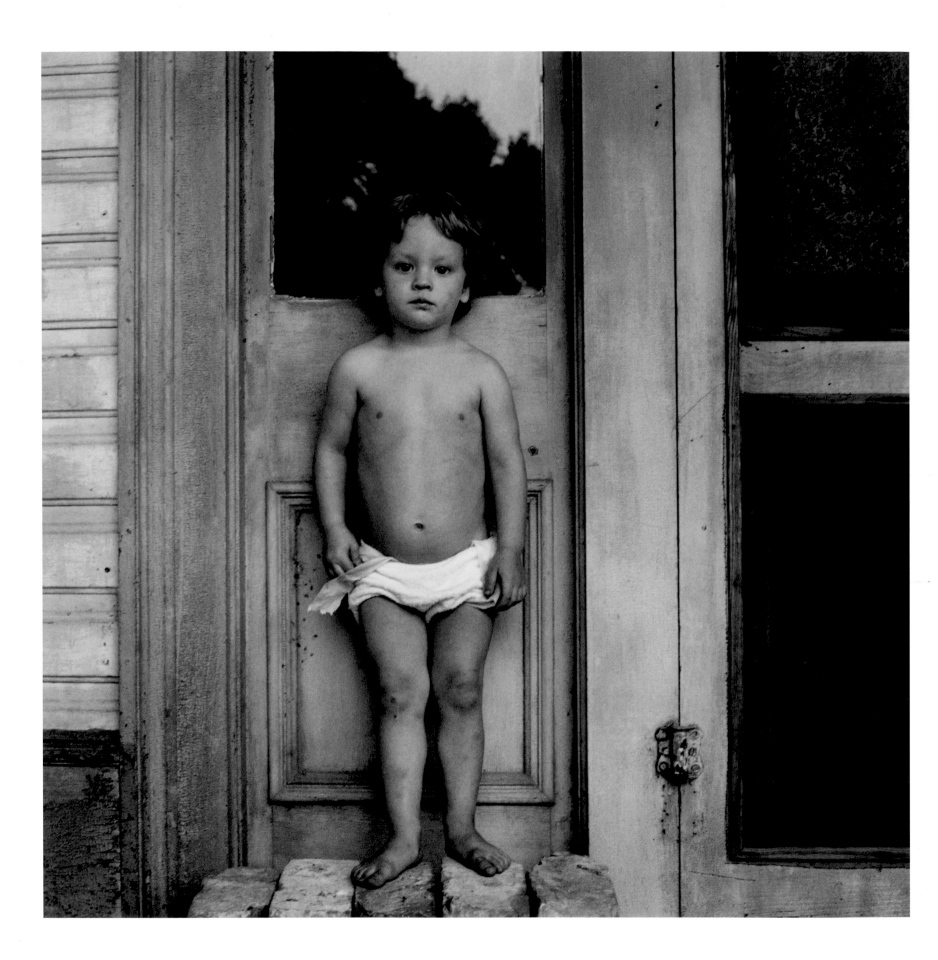

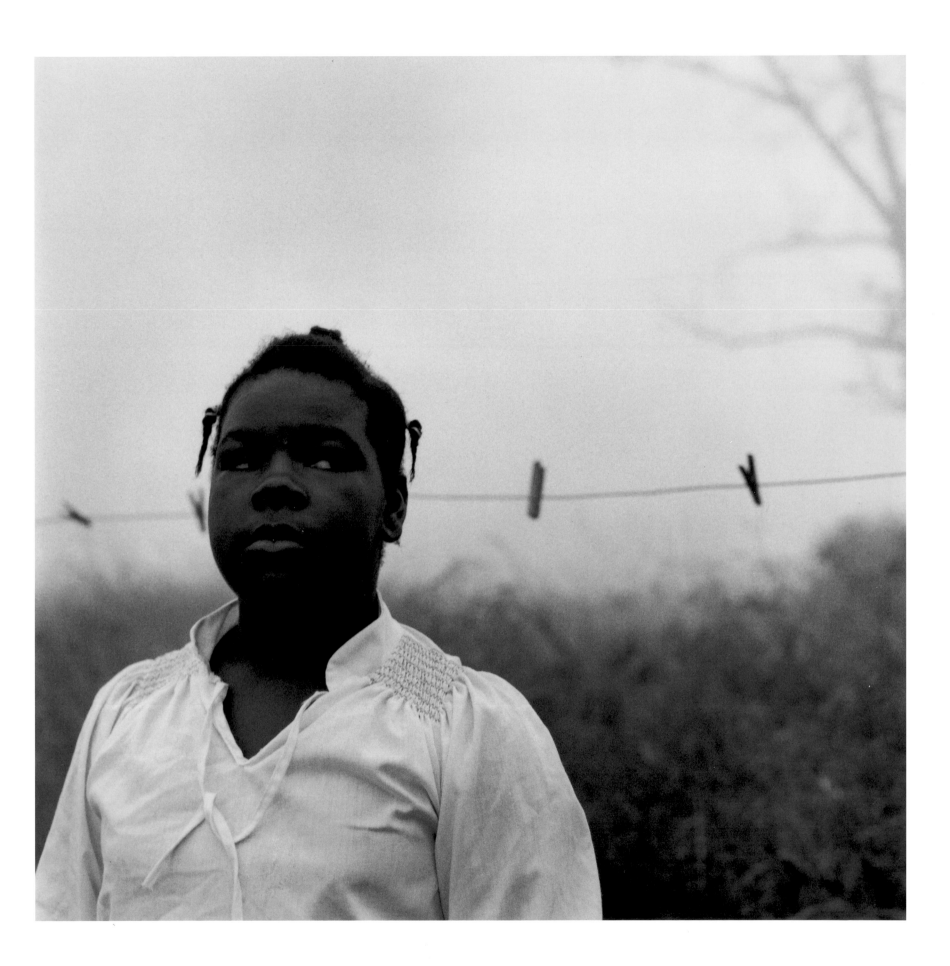

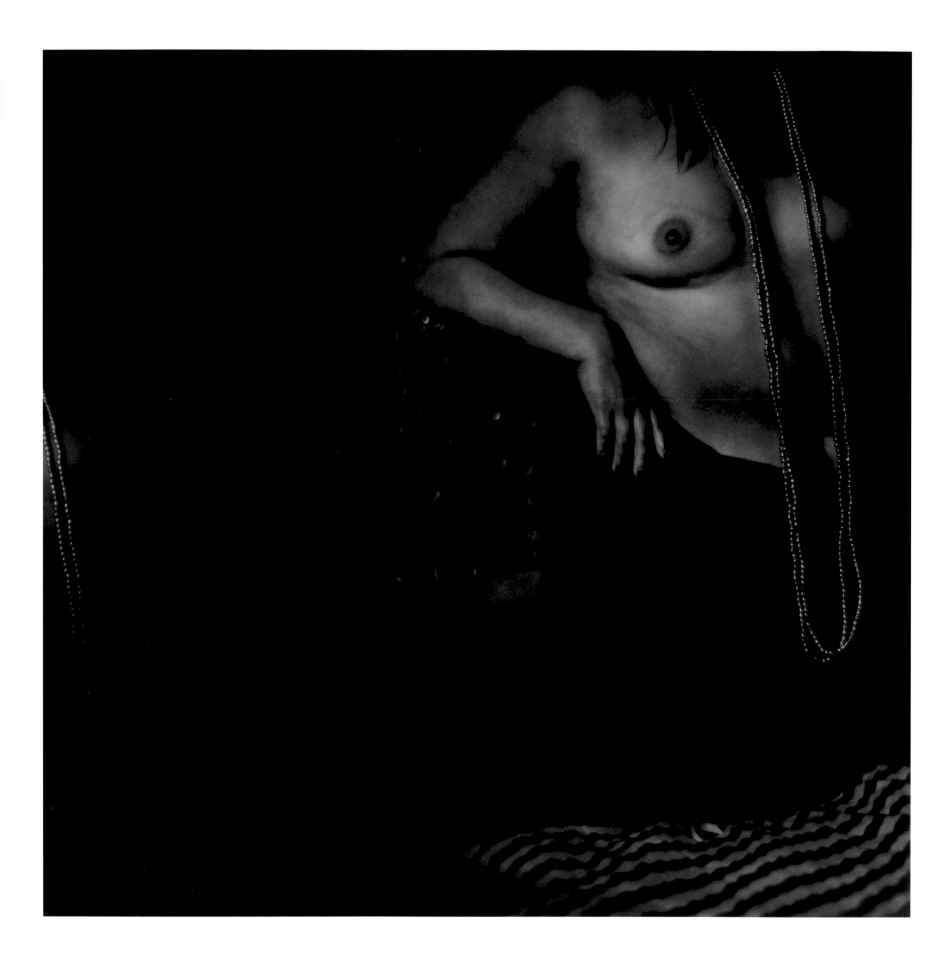

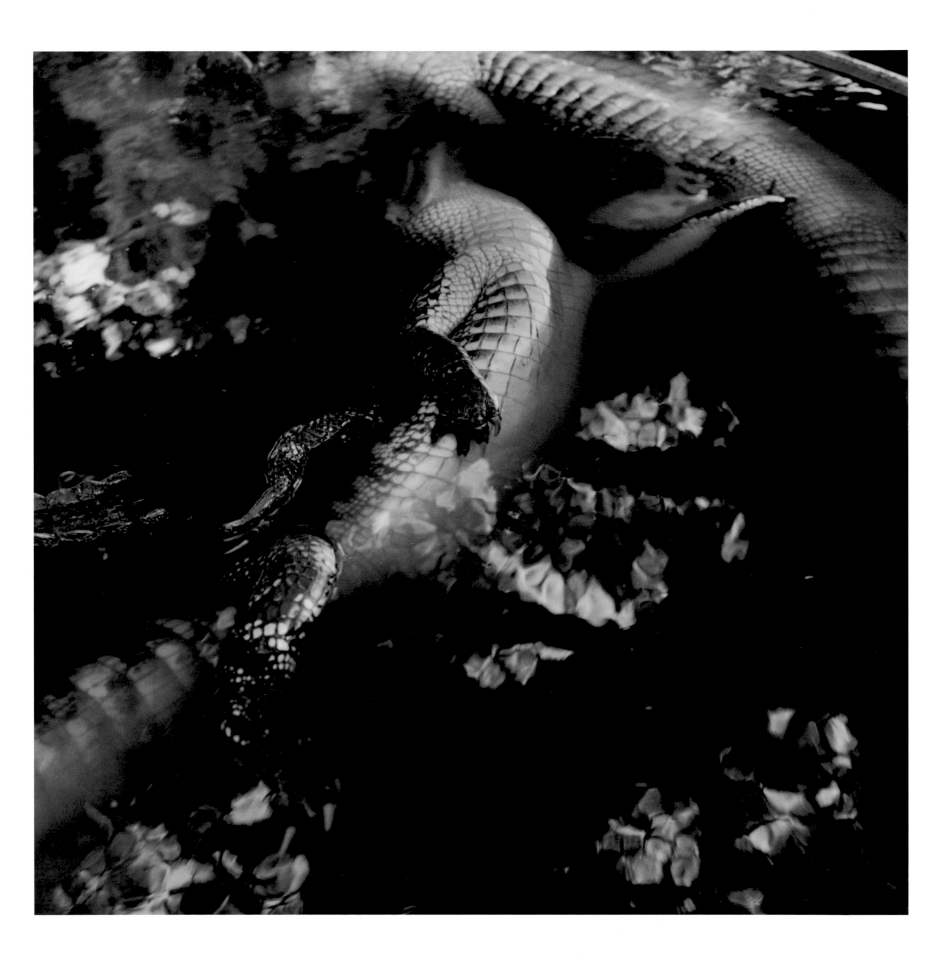

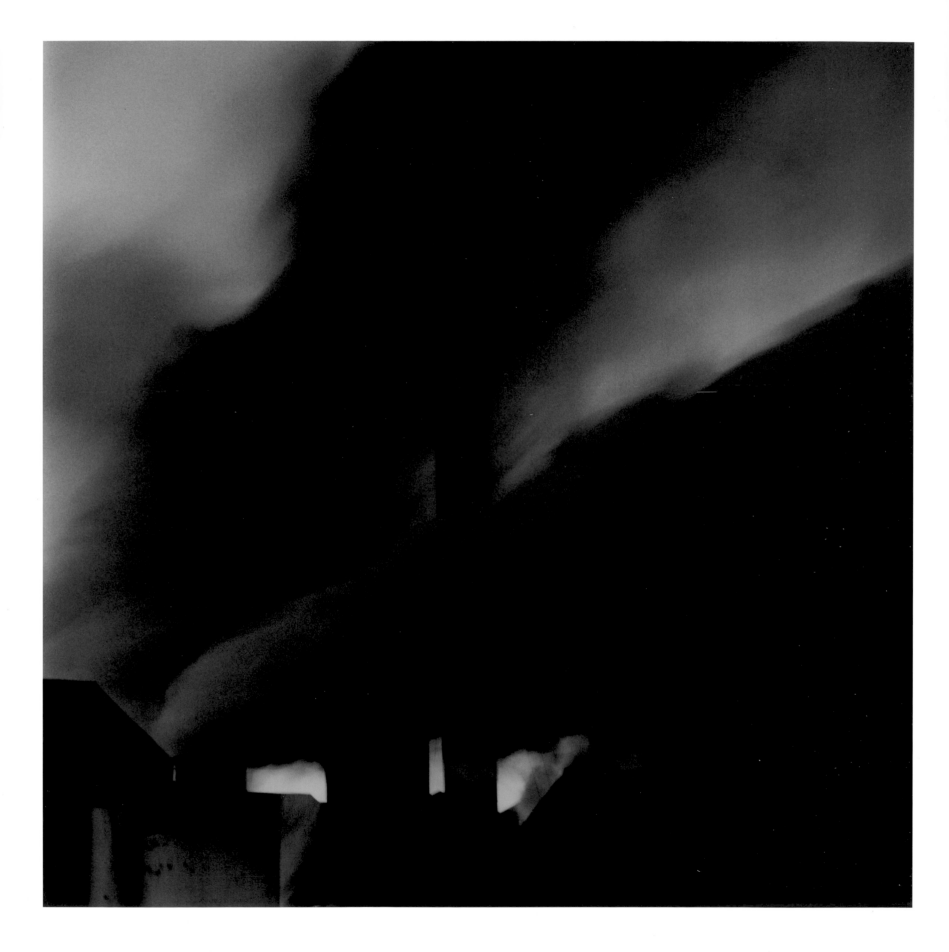

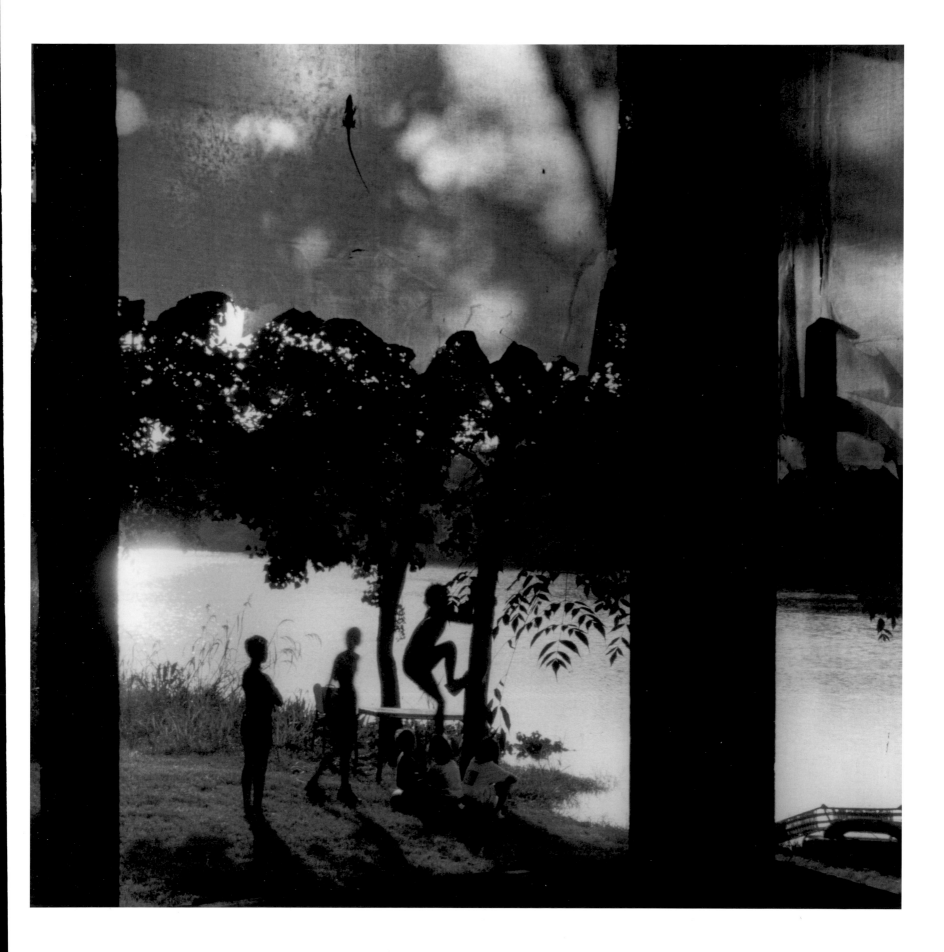

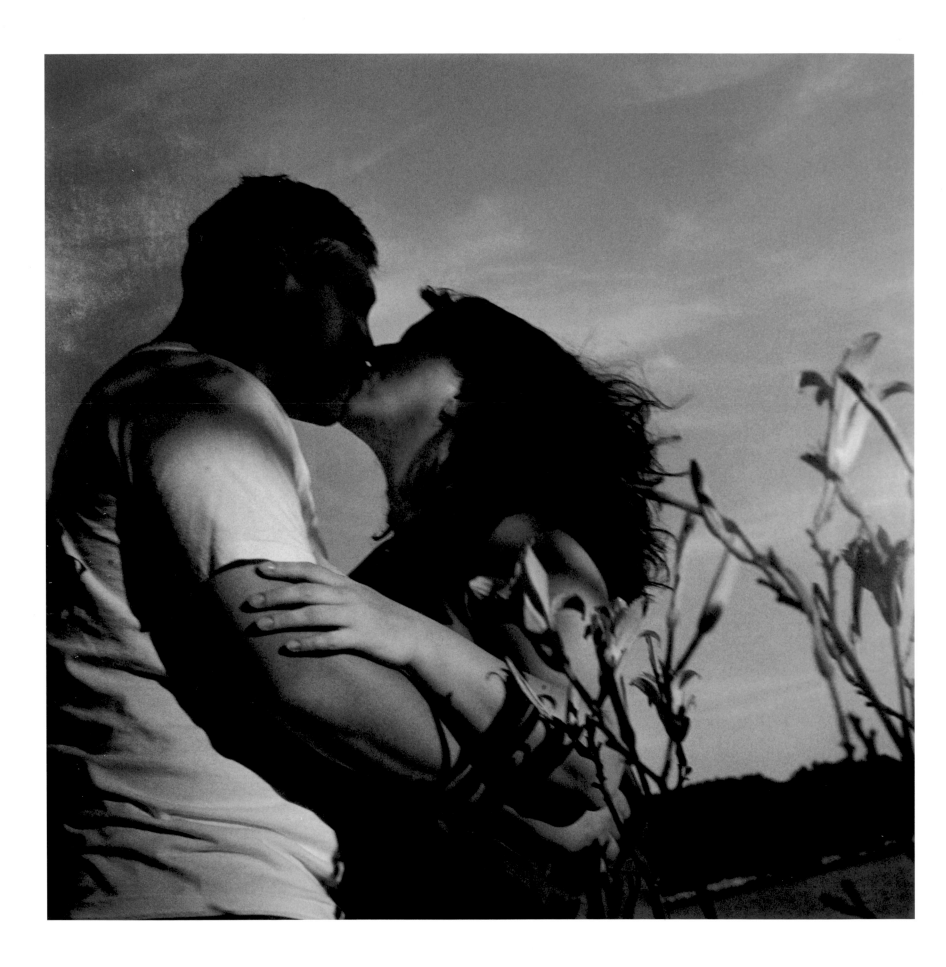

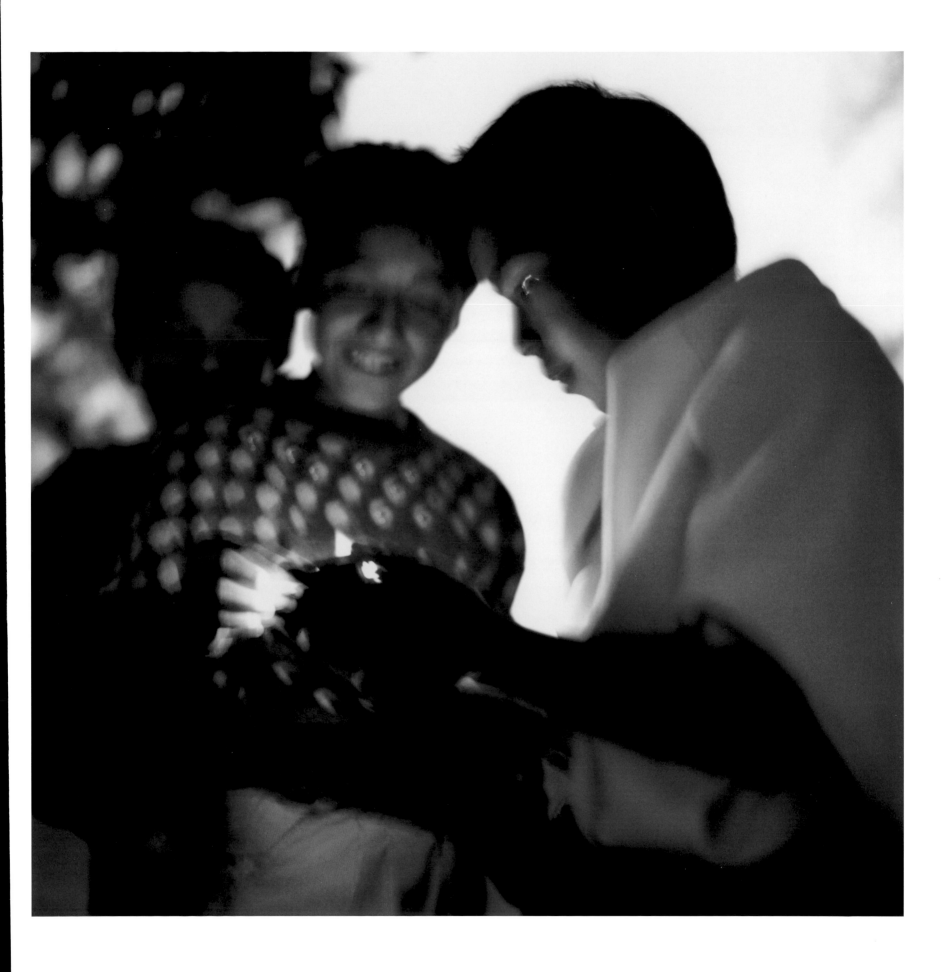

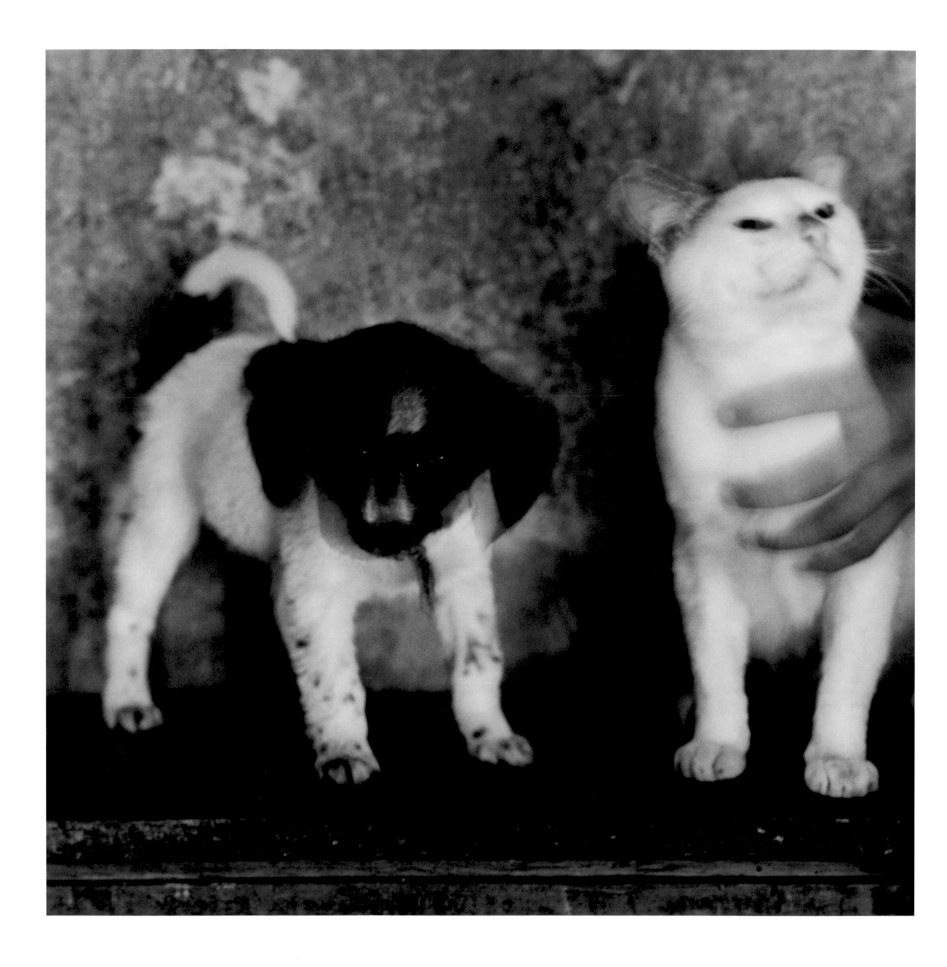

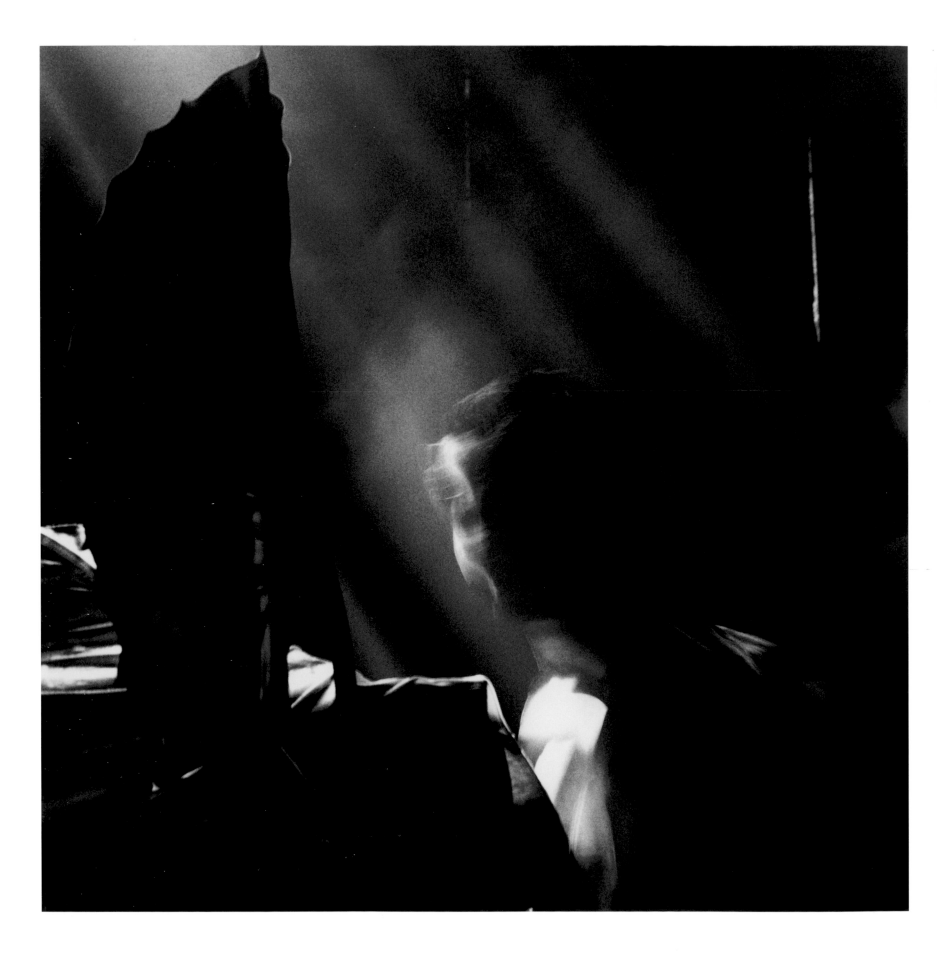

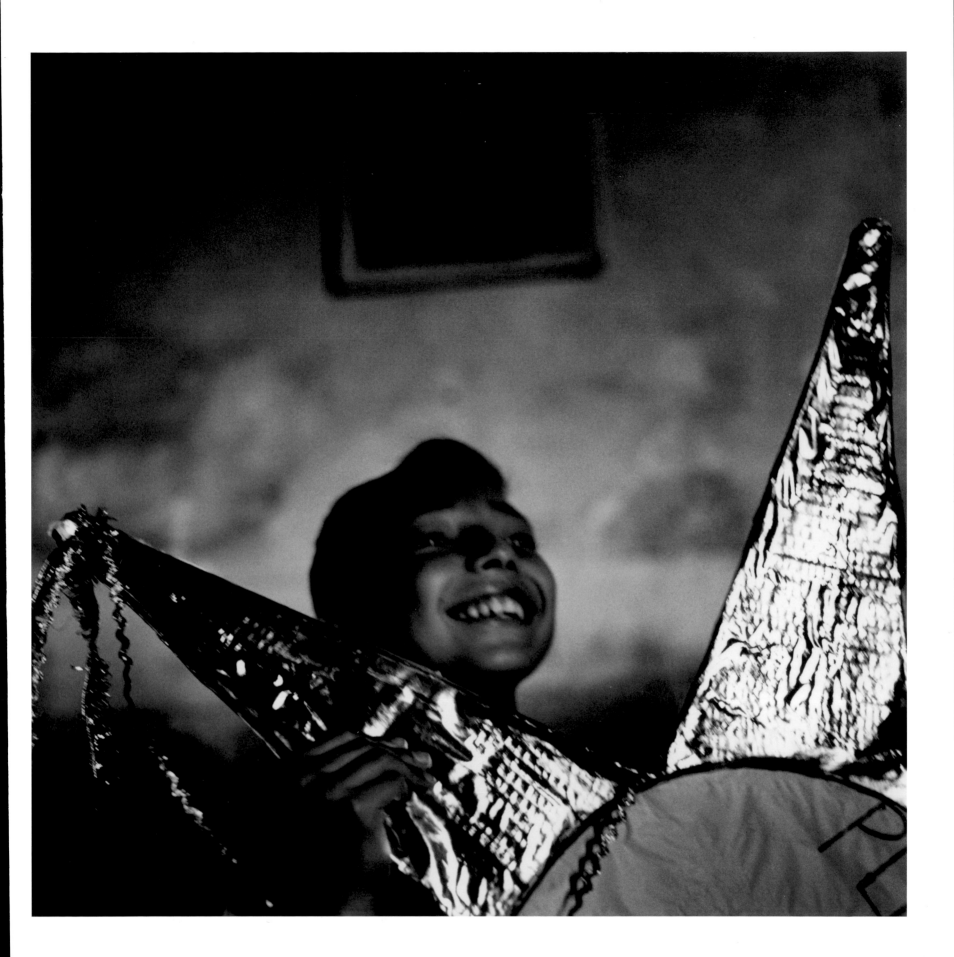

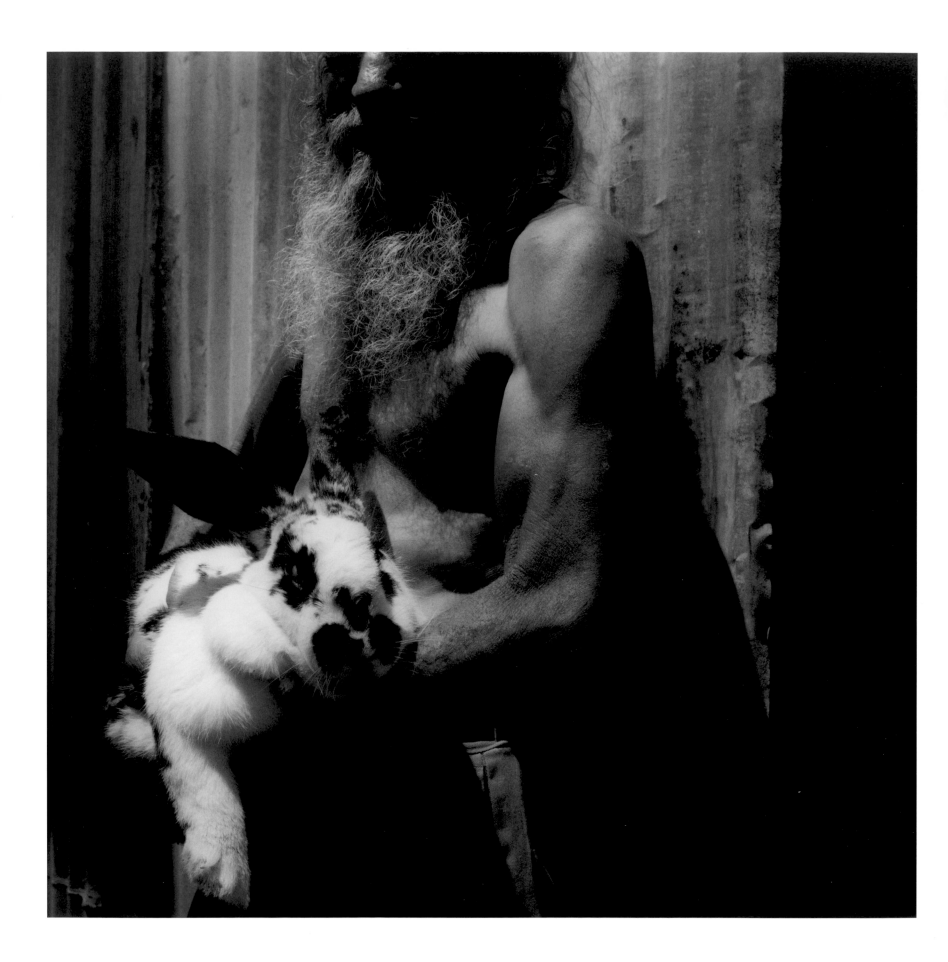

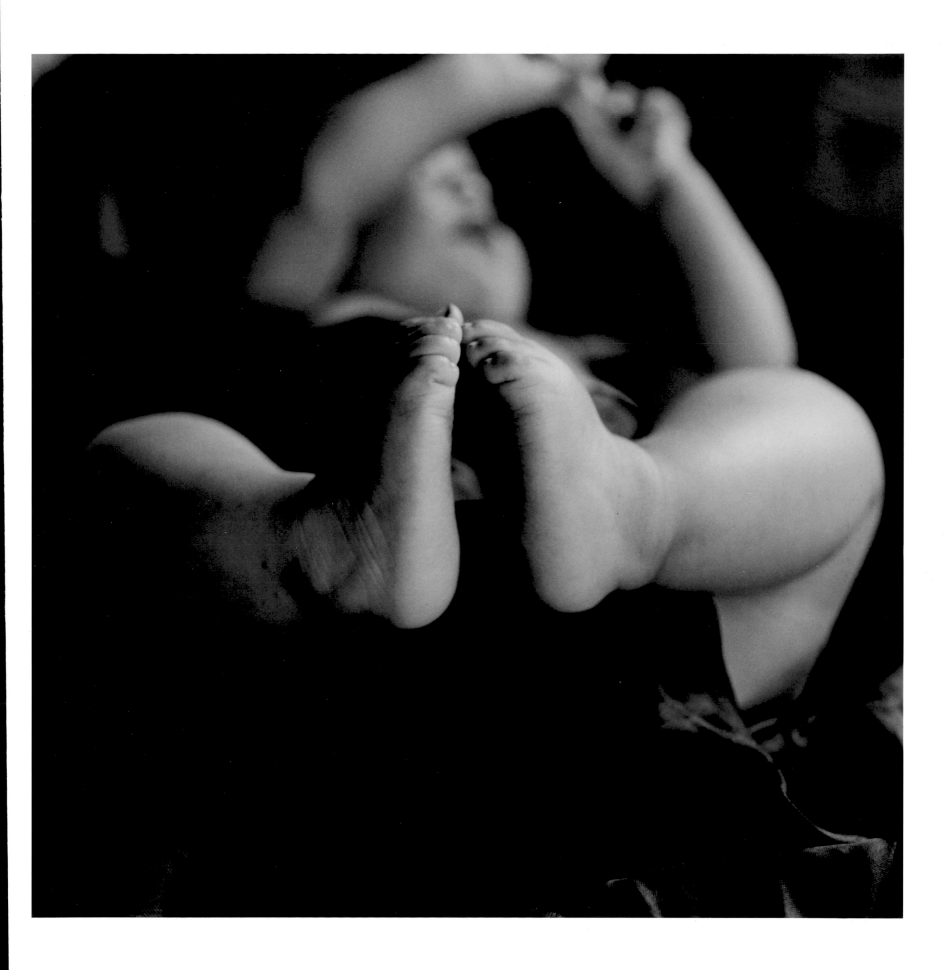

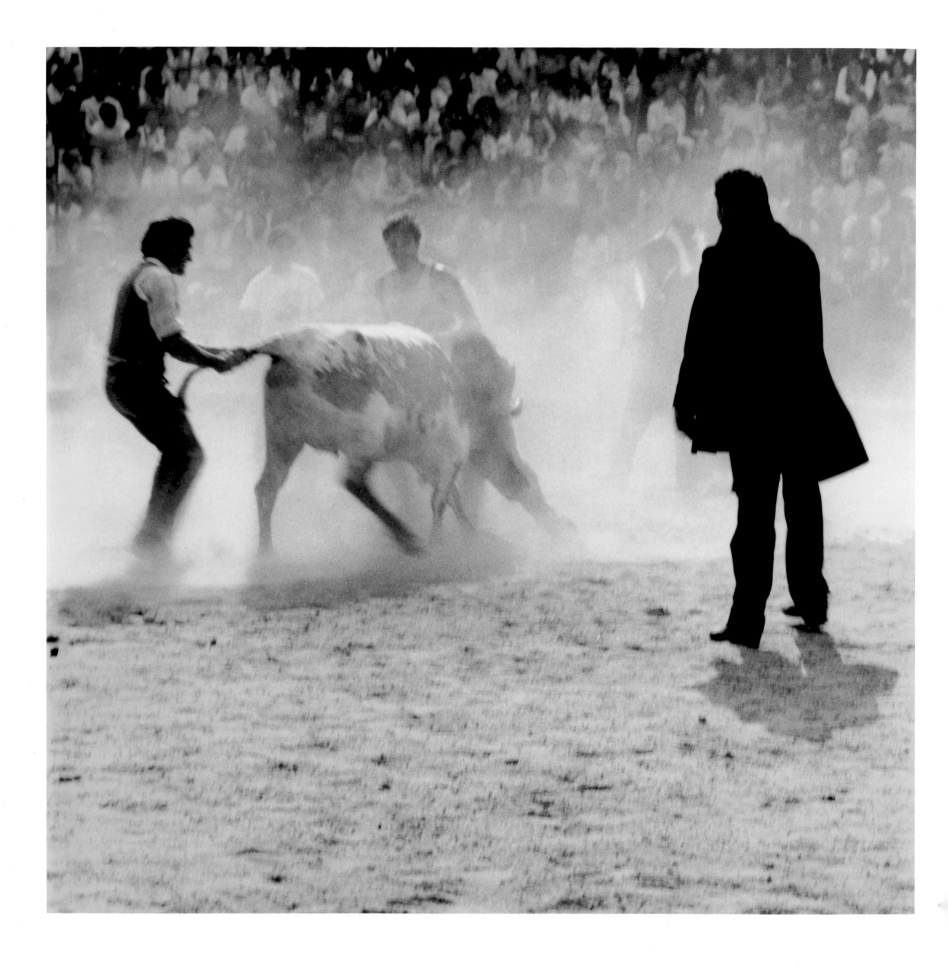

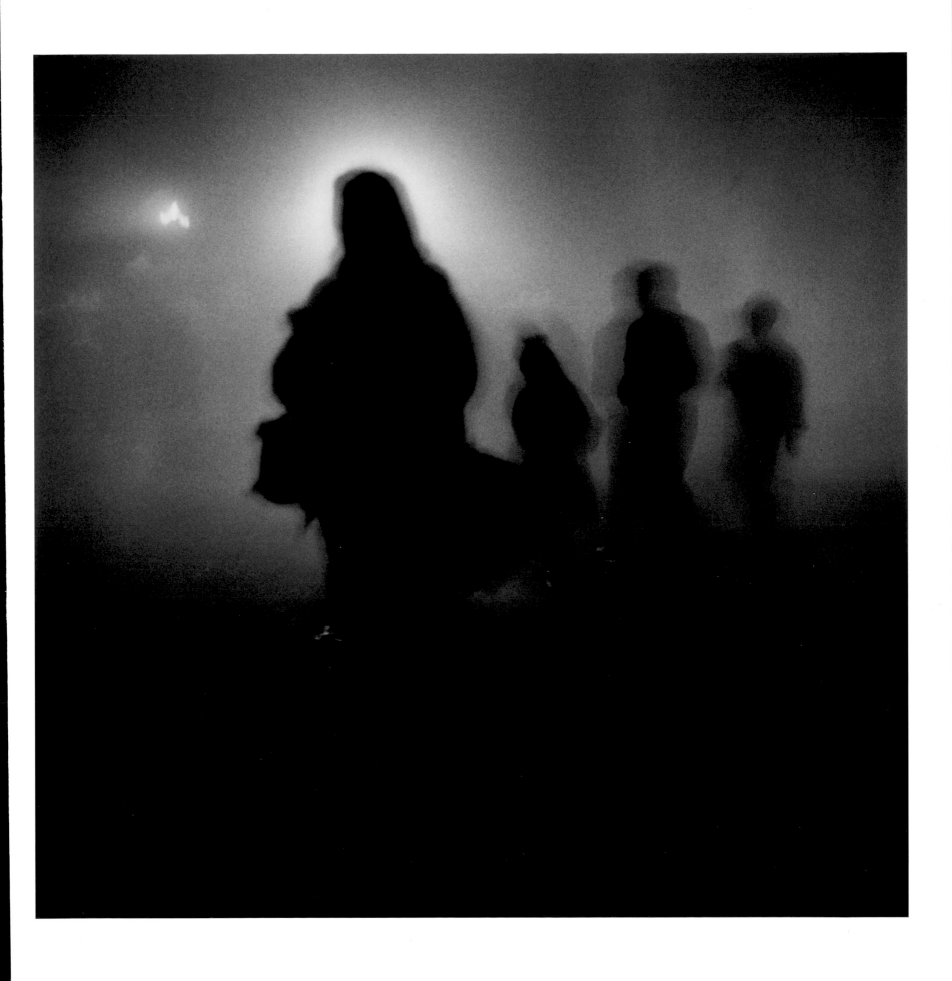

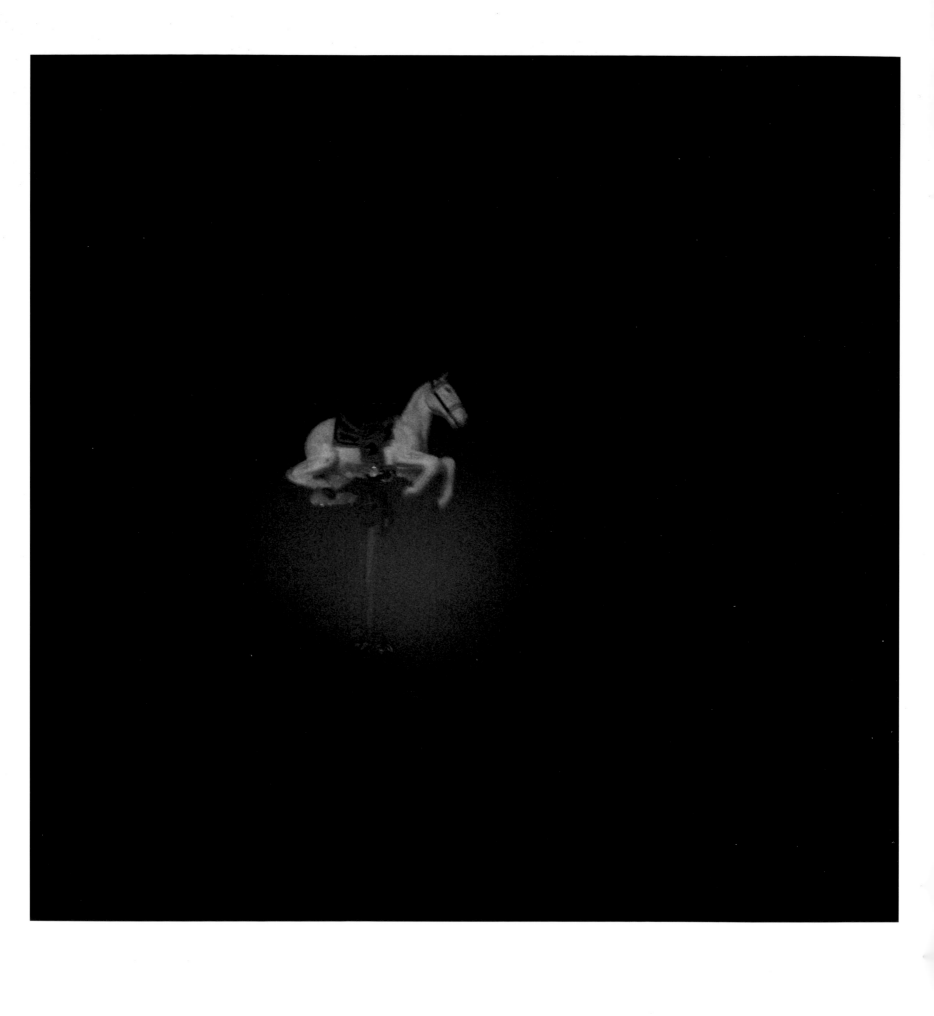

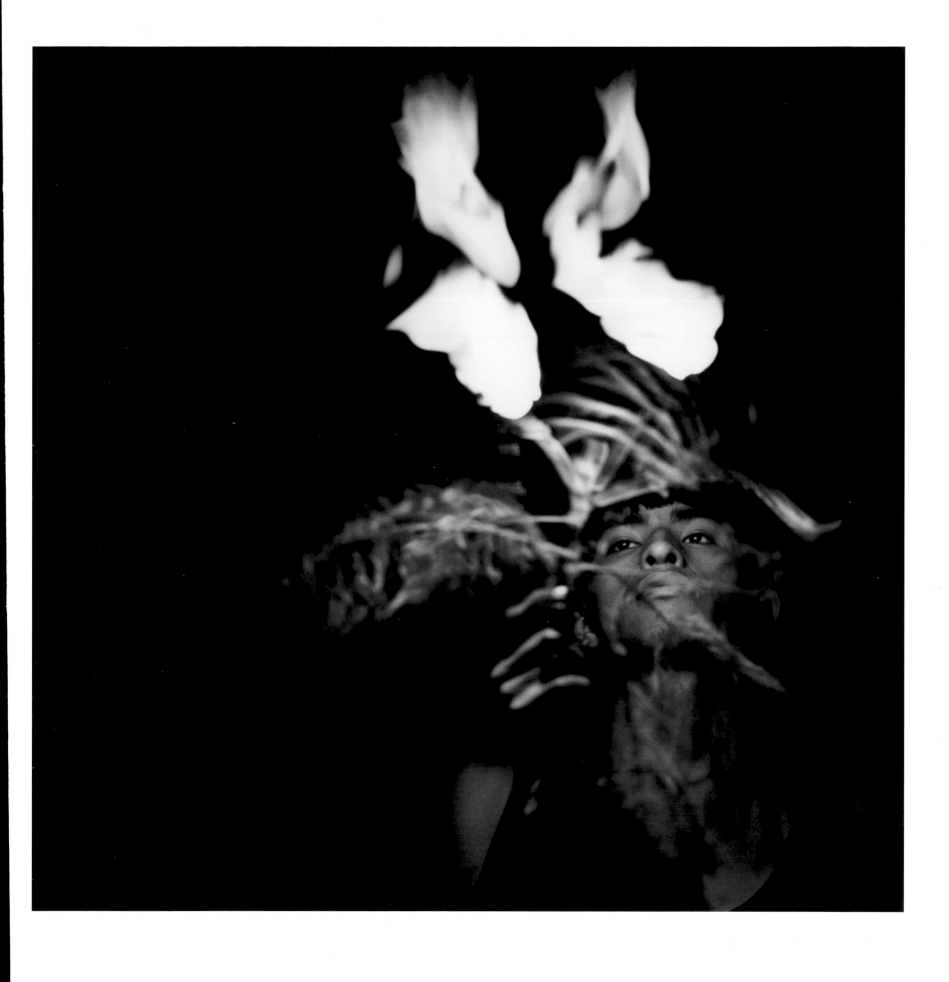

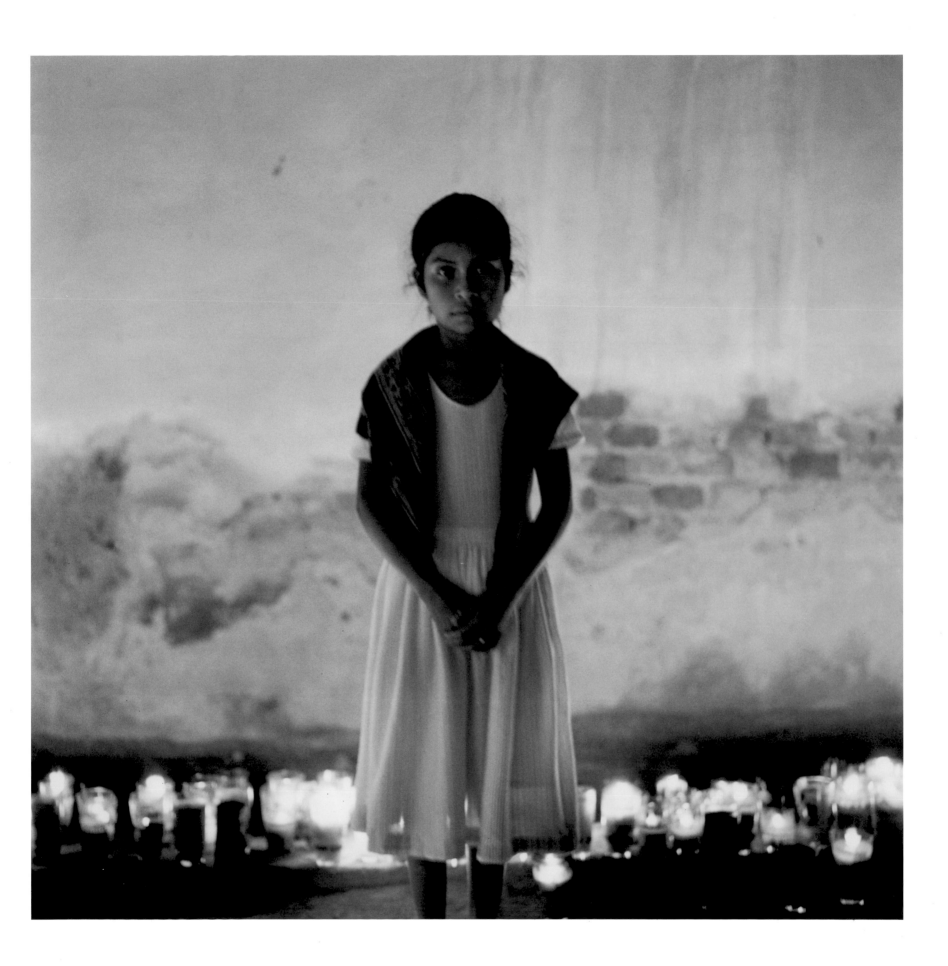

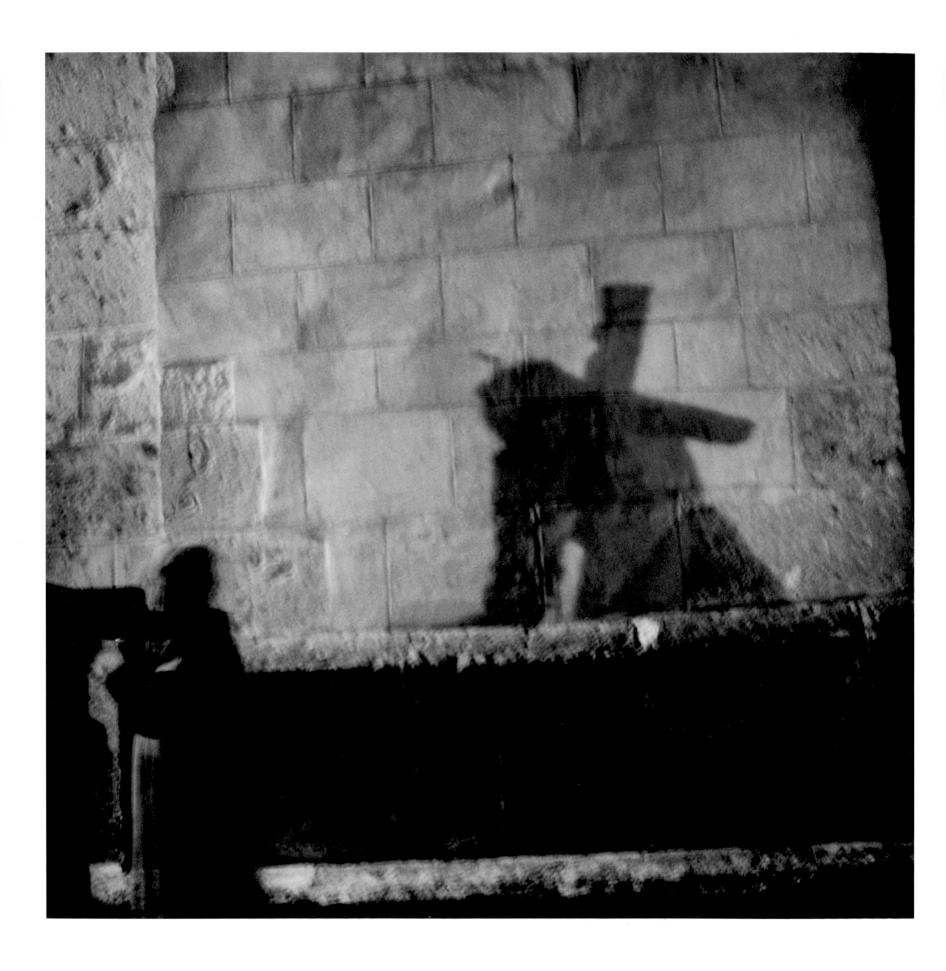

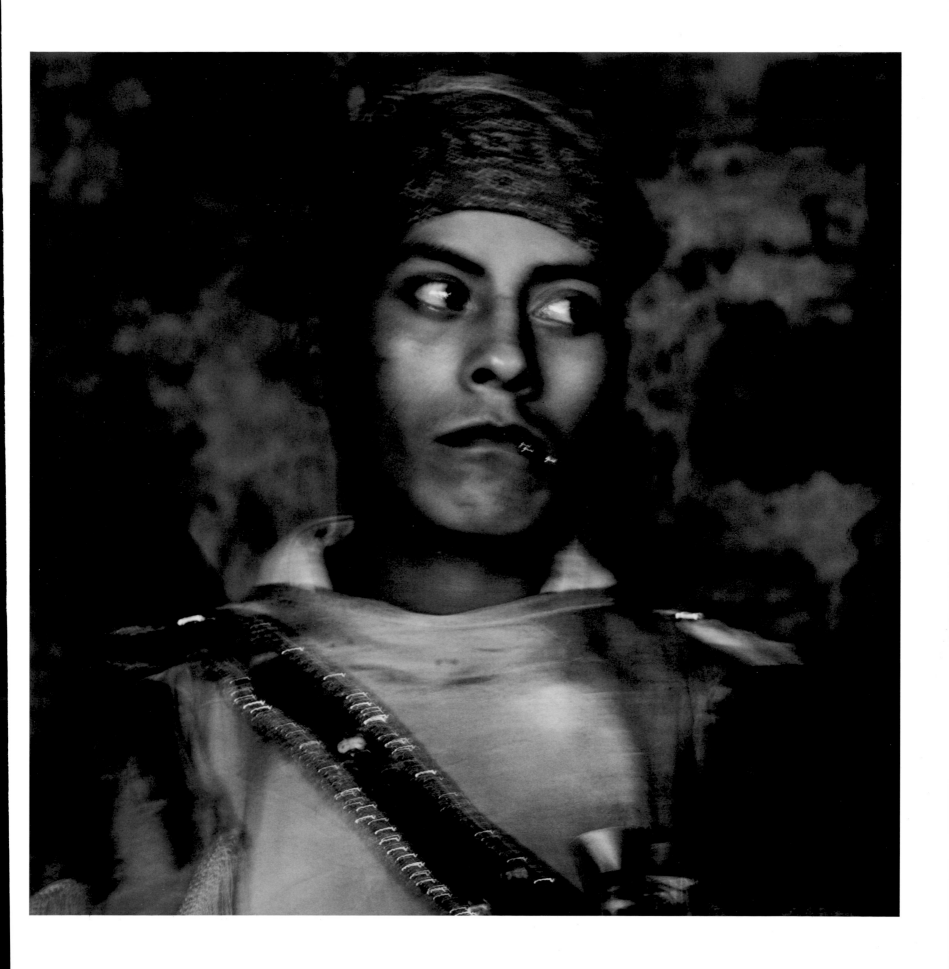

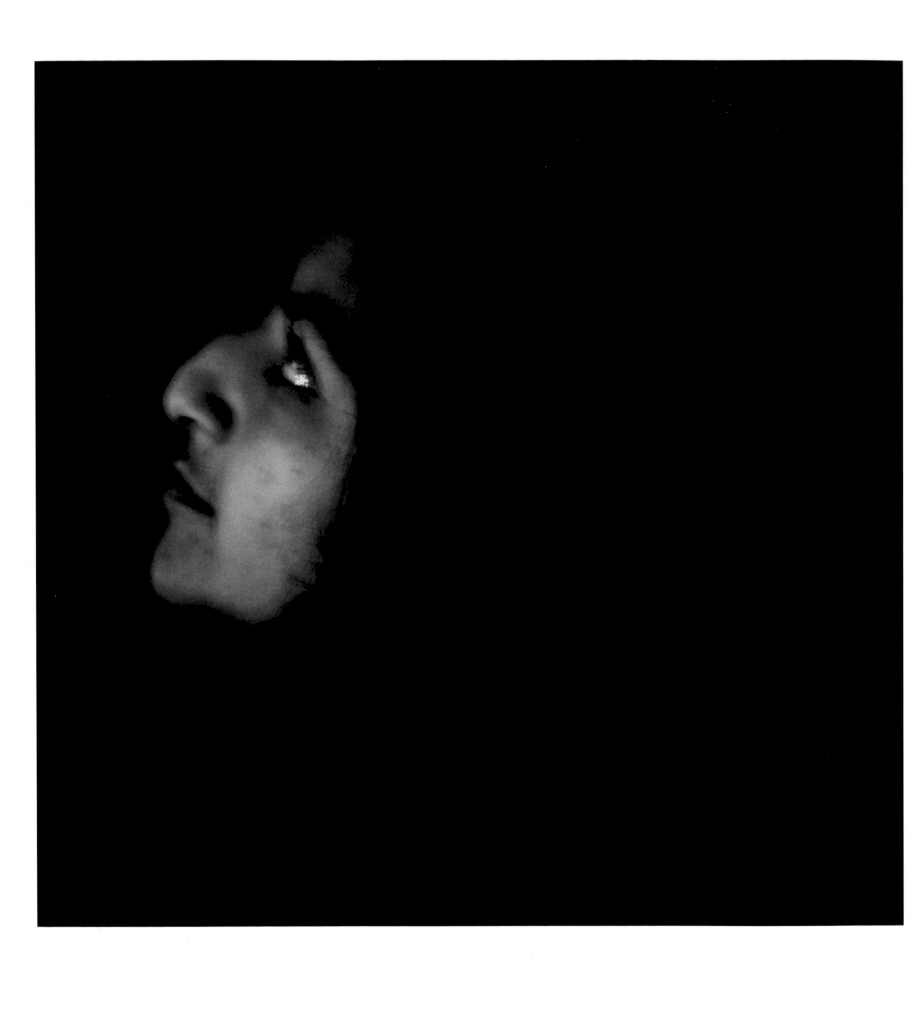

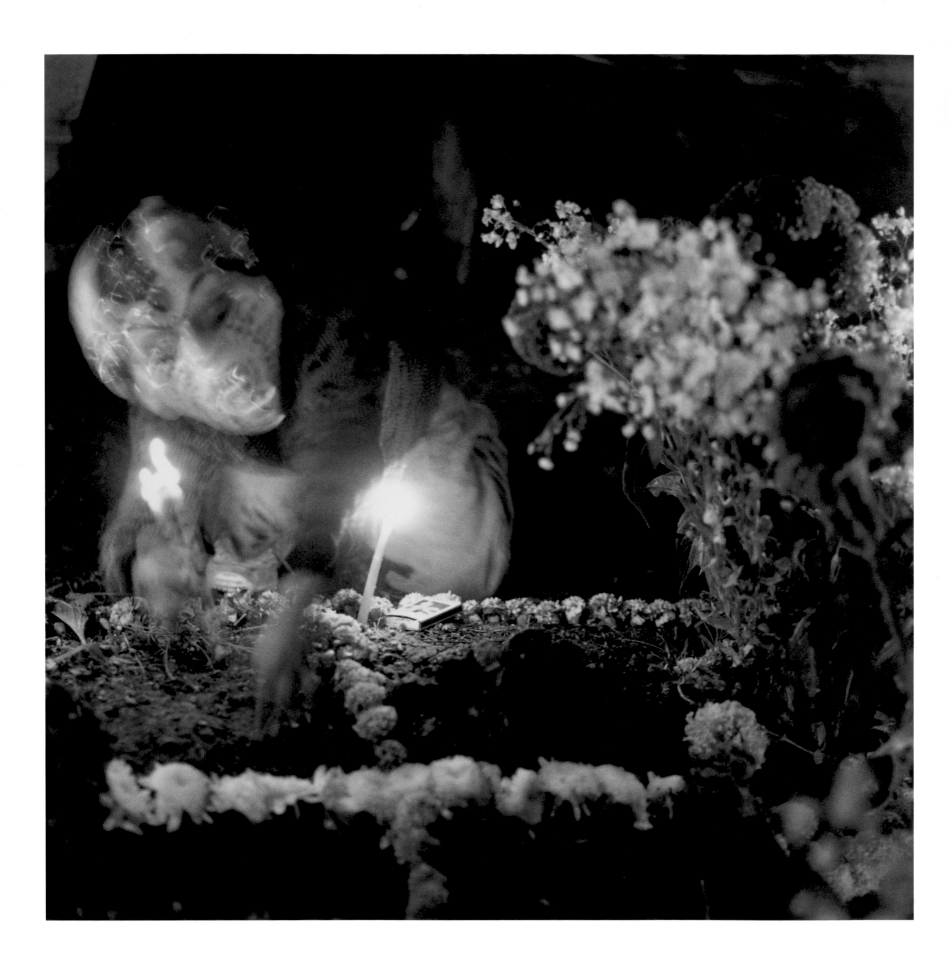

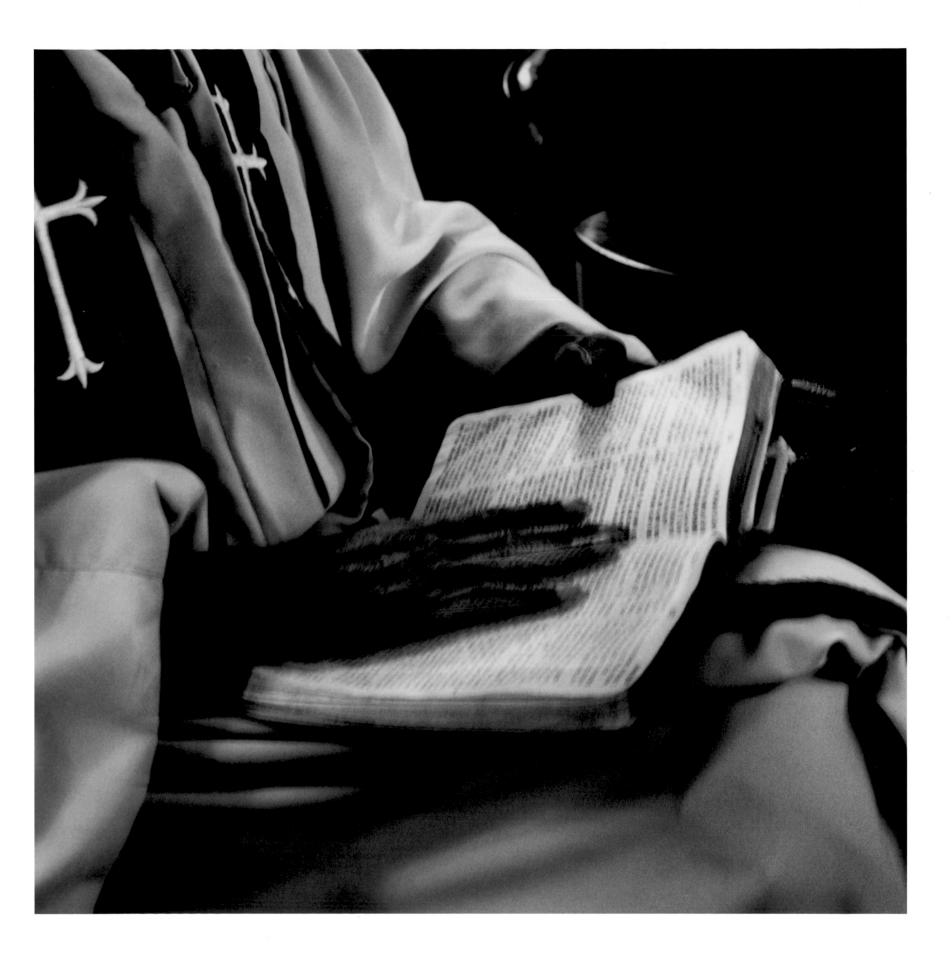

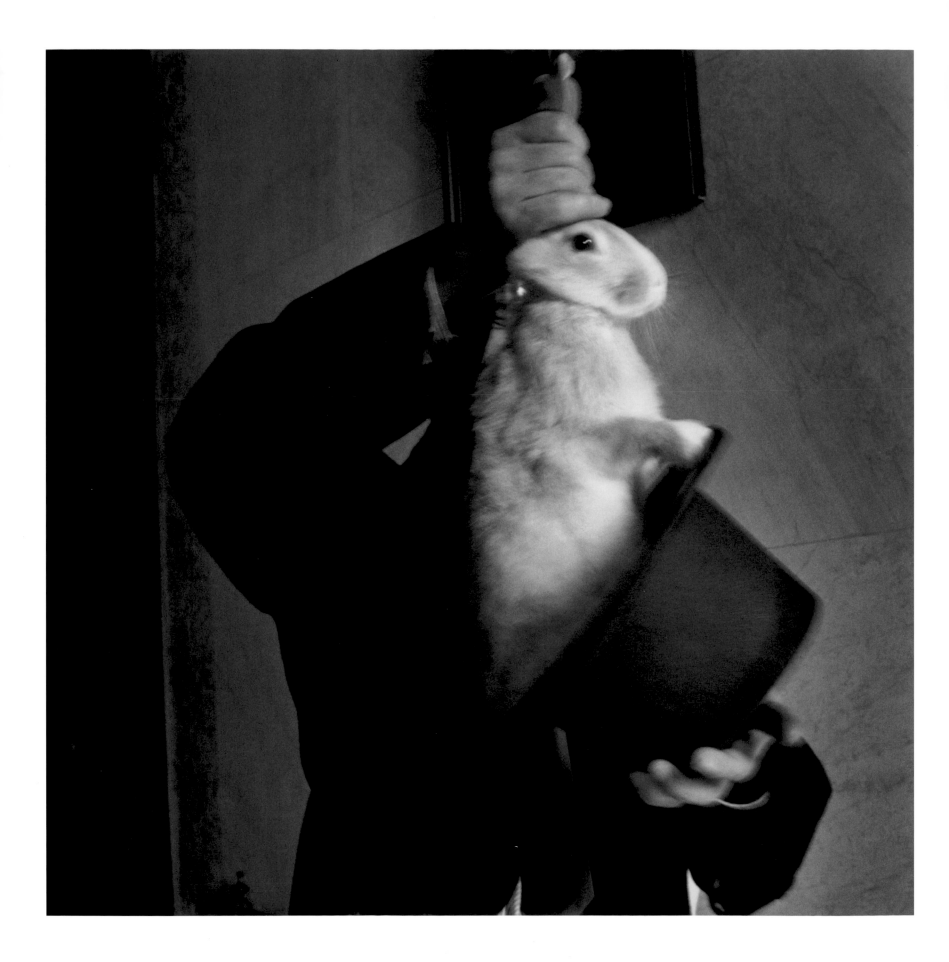

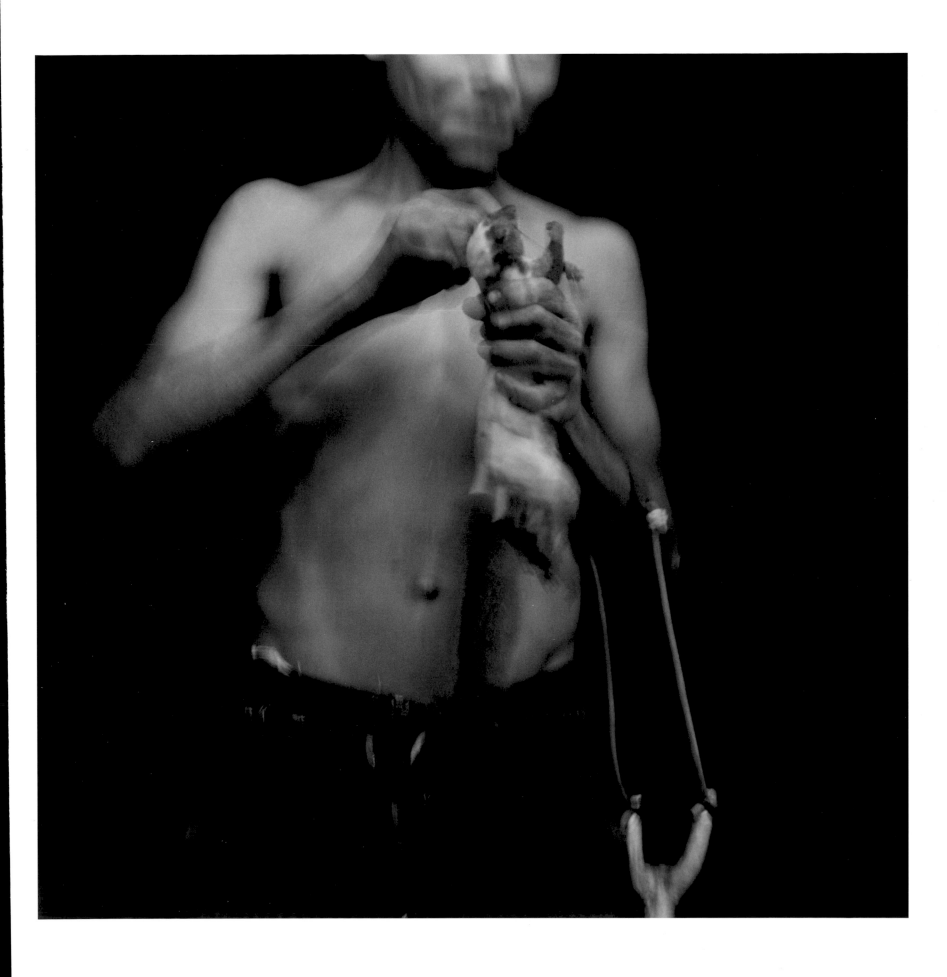

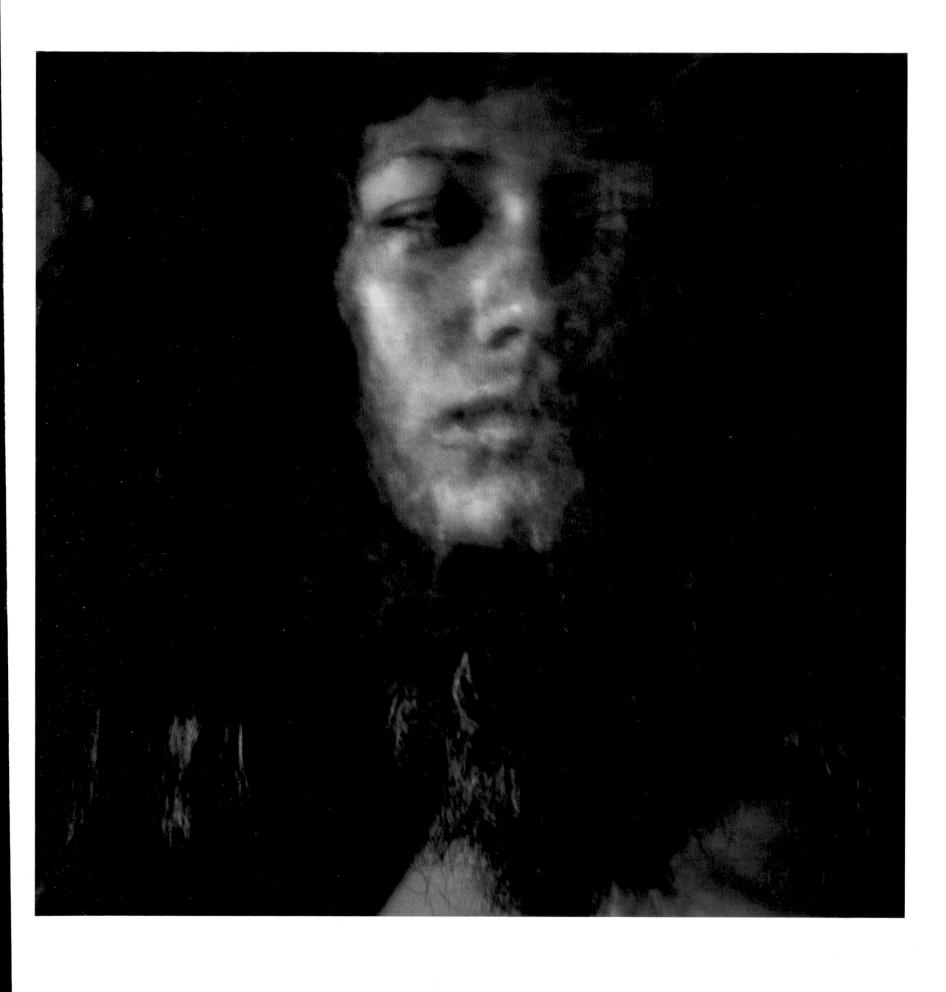

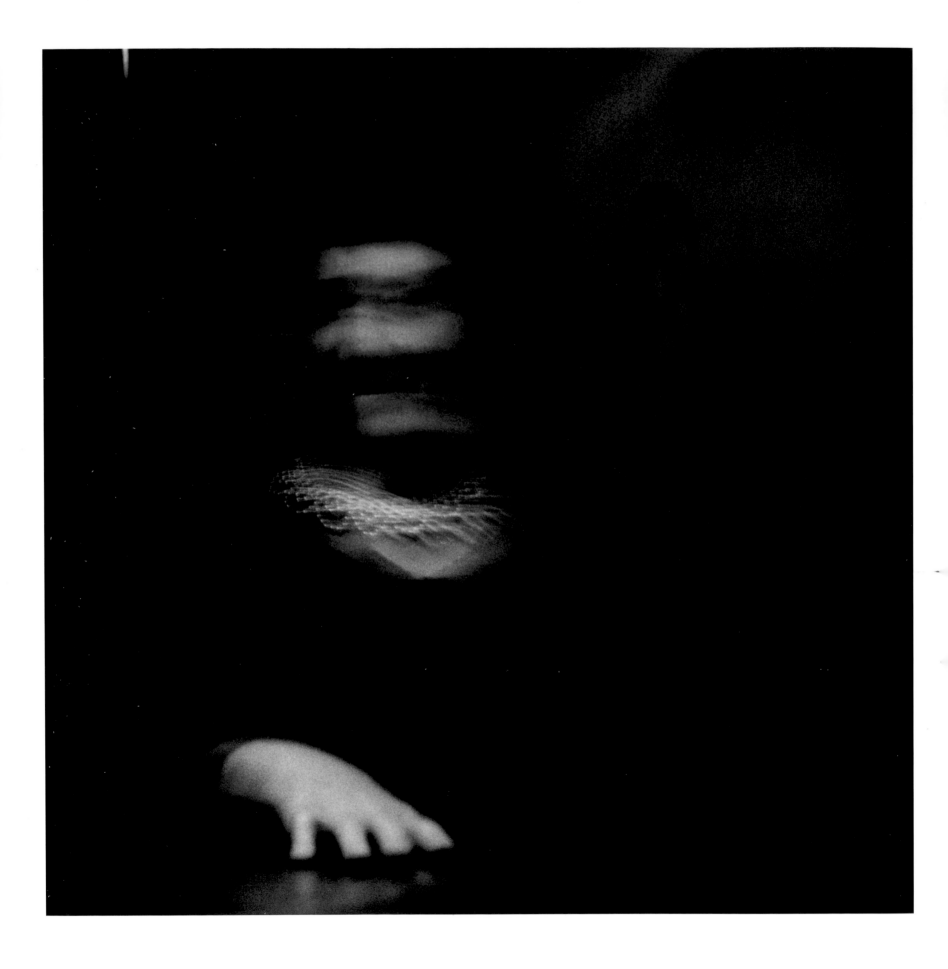

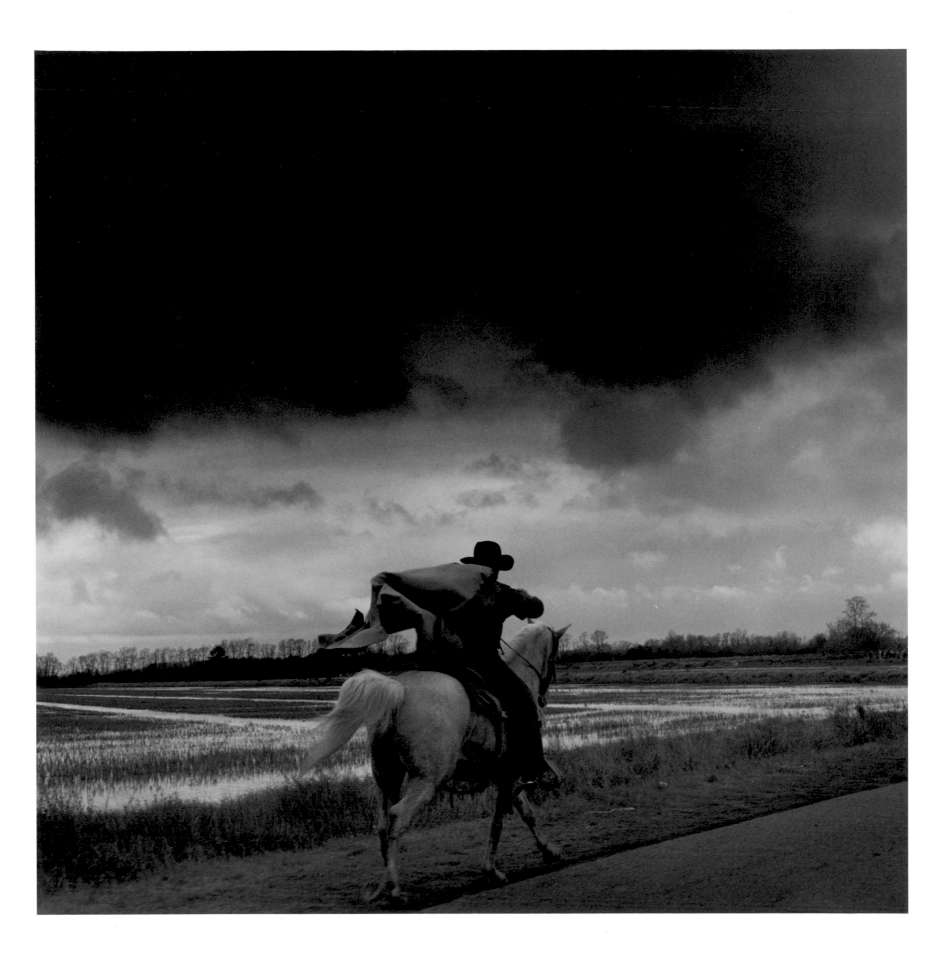

DEDICATION

Joshua, Ruth and
Brennan Caffery

Paul and Kelly Fleming

Thelma Abraham,
Mary Caesar
and Polly Joseph

Jack Woody
and Axel Ziegler

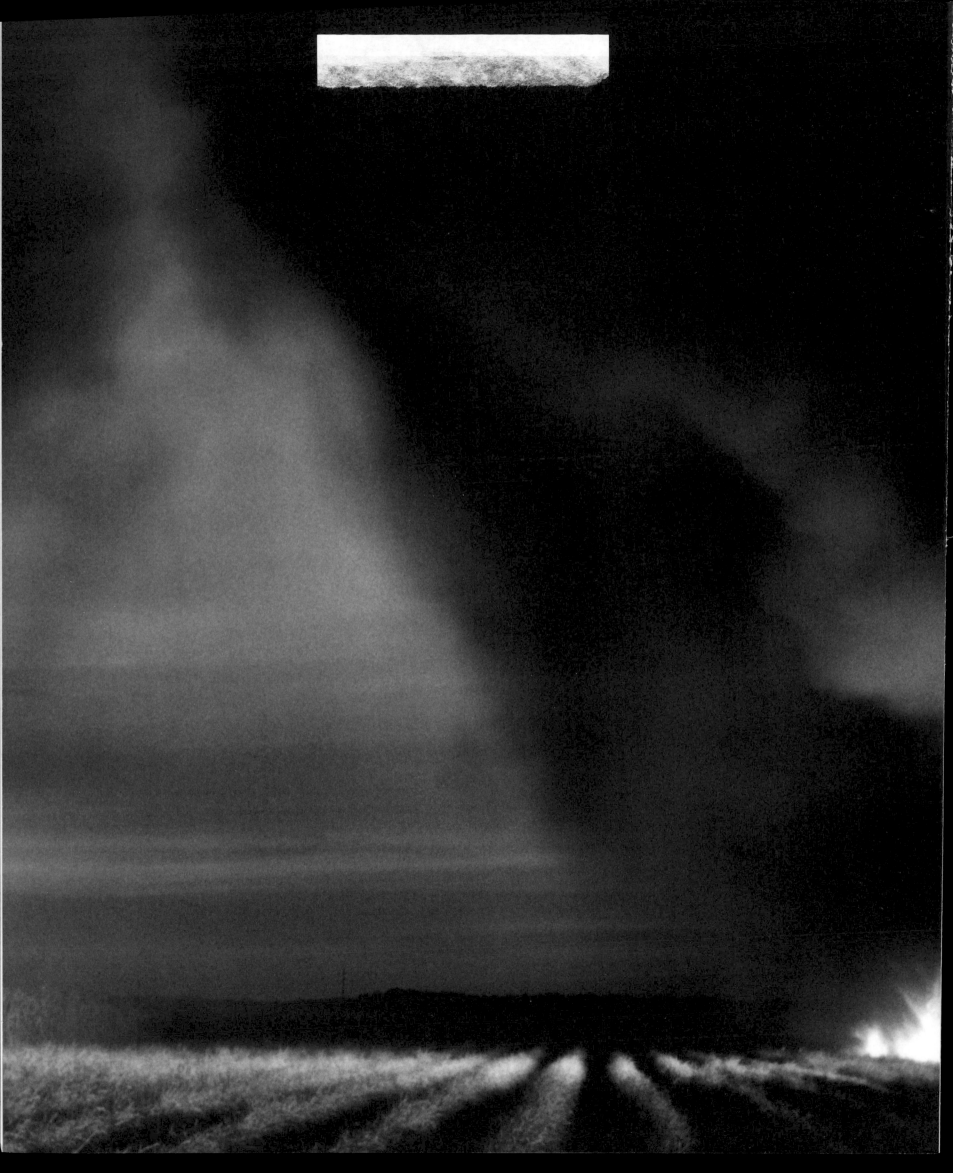

COLOPHON

This first edition of *The Shadows* is limited
to 3000 casebound copies. There is also
an autographed edition of twenty-five
copies in a clamshell box with an original
print, signed by the artist, and a slipcased,
numbered and autographed edition of
one hundred copies. The photographs are
copyright Debbie Fleming Caffery, 2002.
The contents of the book are copyright
Twin Palms Publishers, 2002. Tritone
separations by Robert J. Hennessey. This
book was printed and bound in Amsterdam
by drukkerij Mart.Spruijt, e: mart@spruijt.nl,
on chlorine free, 200 gsm, Hello High silk,
Proost & Brandt, Diemen, The Netherlands.
Book design is by Jack Woody, Arlyn Eve
Nathan, and Axel Ziegler. The typeface
selected is Requiem designed by the Hoefler
Type Foundry.

ISBN 1-931885-12-5
Slipcased edition ISBN 1-931885-17-6
Boxed edition ISBN 1-931885-18-4

TWIN PALMS PUBLISHERS

Post Office 10229 Santa Fe, NM 87504
1-800-797-0680 www.twinpalms.com